NATIONAL GEOGRAPHIC
PHOTOGRAPHY
FIELD GUIDE
DIGITAL

NATIONAL GEOGRAPHIC
PHOTOGRAPHY
FIELD GUIDE
DIGITAL

SECRETS TO MAKING GREAT PICTURES

Text and photographs by
ROB SHEPPARD

NATIONAL GEOGRAPHIC
WASHINGTON, D.C.

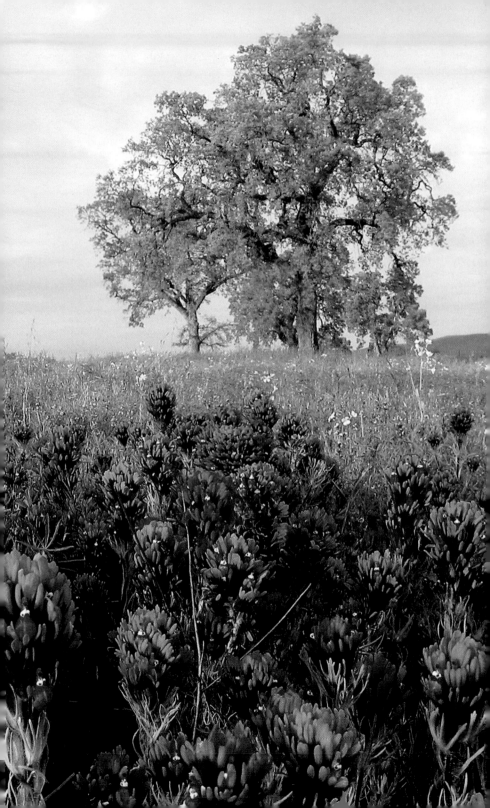

CONTENTS

PAGES 2-3: A digital camera with a rotating LCD panel allowed this landscape photograph to be captured from a unique point of view— down in the owls clover flowers.

Rob Sheppard

OPPOSITE PAGE: From the traditional to the fantastic, much is possible with digital photography.

Bruce Dale

It's All Photography

PHOTOGRAPHY, IN ITS MOST BASIC FORM, began in Europe more than 150 years ago. But now, with the fast-paced introduction of digital photography, it almost seems to have made a new beginning. We are in the midst of a revolution, a digital revolution.

This change in how we take pictures has affected photographers, from beginners to advanced, in many different ways. At first, a lot of traditional photographers saw what the computer could do and grew worried. What would the digital revolution mean to photography?

Regardless of what people might have thought about digital a few years ago, this technology is not only here to stay but also increasing in popularity. Digital camera sales are growing at a phenomenal rate, and film sales are steadily declining as film gives way to the sensor and memory card. At all major newspapers, photojournalists now rely mostly on digital technology. In the most recent Winter Olympics, 20 percent of the accredited professional photographers shot only film, and today all *Sports Illustrated* staff photographers shoot digital.

Some professional photographers take up digital photography with great reluctance and then discover that this technology isn't so alien after all! Consistently, I find them falling in love with photography again. The digital revolution

Digital photography has become such a part of our visual world that even NATIONAL GEOGRAPHIC photographers rely on it for images like this dramatic dinosaur cover.

Robert Clark

NATIONALGEOGRAPHIC.COM · AOL KEYWORD:NATGEO · MARCH 2003

NATIONAL GEOGRAPHIC

dinosaurs
Cracking the mystery of how they lived

Puerto Rico: The State of the Island 34 PLUS West Indies Map
Sky-High in Wildest Alaska 56 Qatar's Move Toward Democracy 84
Pacific Hotspot 106 Lemongrass on the Prairie 126

is no death knell for photography; instead, it is a rejuvenating makeover.

Why? Because digital pictures are photographs, too, and taking them encourages photographers, whether amateur or pro, to improve their skills and experience anew the joy of photography. I hope this book will encourage and support your use of this technology so that you, too, will become a better photographer and enjoy the experience.

Some people have gotten the wrong impression about digital photography and come to believe that it is mostly about computers and electronics. One esteemed old-line pro recently remarked in an interview on National Public Radio that the digital revolution had ruined the craft of photography. Obviously, he had not done much digitally, because all photography is art- and craft-based; otherwise, a book like this would have very few pages.

Digital photography can make it easier for beginners to learn photography and for others to become better at what they do. Whether you are a purist searching for photojournalistic truth or a fanciful artist ready to create totally new ways of photo-illustration, this guide will offer you the chance to master digital photography without it mastering you.

Bear in mind, though, that digital photography will not necessarily make you a great photographer. It still starts with an image and your connection to it. Whether you are a world traveler taking pictures on the steppes of Mongolia or a parent lovingly capturing your child's first soccer game, your love of the subject and your continuing practice with digital photography will help make you proud of the photographs you take. No computer can do that.

I will share a secret with you: The photograph—

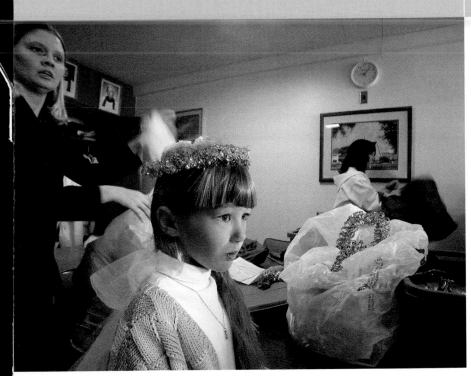

not the technology—is always the most important thing. Technology changes; good photography does not. I've found that when people get confused by digital cameras, working through the digital darkroom or making prints, they almost always find it helpful to take a deep breath and think about their goals: taking better photos and feeling good about their images.

The book parallels the order in which we photograph. We take a picture, have it processed, and use it as a print or share it in some other way. In these pages, we'll explore what's needed to get good photos when we squeeze the shutter; we'll also go over special techniques that digital cameras let us use. Next we'll look at how we get photos into a computer and how we can navigate a digital darkroom. Finally, we'll discover how to make great prints from digital images.

Through it all, I'll keep my own admonition in front of me: It's still photography!

Regardless of the camera type, the photograph is ultimately the most important thing. From photojournalism to family photos, digital photography is still photography.

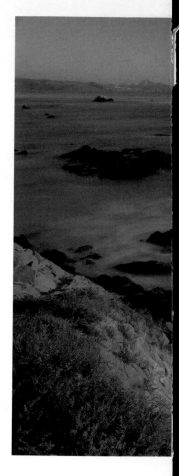

What are Digital Cameras?

THE BASIC TOOLS OF PHOTOGRAPHY have long been cameras and film. Even nonphotographers can recognize cameras, from point-and-shoots to 35mm single-lens reflexes (SLRs). It's often possible to identify certain types of photographers just by the equipment they use: A big, boxy view camera and tripod, for example, could belong to a landscape photographer; a long-lensed SLR might be found in the hands of a wildlife or sports photographer; and a larger handheld camera and flash might be used by a wedding photographer. Fair observations or not, these are recognizable stereotypes.

But what of the digital camera? It seems to have developed an aura and identity separate from traditional photography.

Digital cameras now show up everywhere. You can't go to a major event without seeing amateurs holding up their cameras to look at the back-mounted monitors. Watch a professional photographer at a football game or other sporting event, and you'll probably see the unique back of a digital camera.

Portrait photographers have discovered that nearly all of their subjects actually like having their pictures taken with digital cameras because they can see the results instantly. Travel photographers no longer have to worry about missing shots while traveling; they can check their images

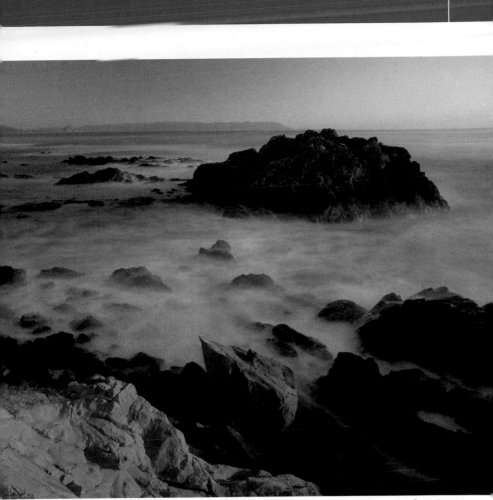

George Lepp

as they go and reshoot while still on location. Nature photographers can try different techniques, such as flash and wide-angle close-ups, learning from their experiments while still photographing their subjects.

Digital cameras today offer superb image quality that competes directly with film. These cameras look and act like traditional cameras with a few extra features. Tricky camera designs are quickly leaving the marketplace because photographers want to take pictures and not be bogged down by hard-to-use technology.

With a digital camera and its LCD panel, the photographer saw the effect of using a dense neutral density filter and then opted for a slower shutter speed to create a unique image of ocean waves.

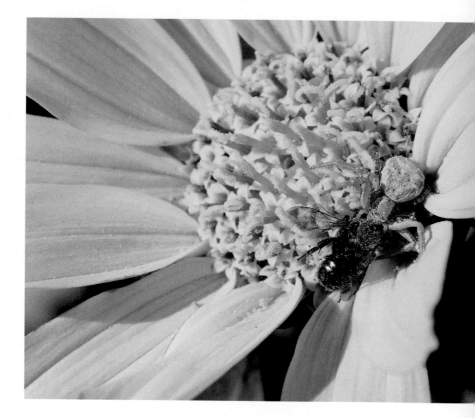

Close-ups such as this photo of a crab spider capturing a small bee are even easier with a digital camera; you can check an image on the LCD panel to be sure you get what you want.

Continuing the Tradition

Many things about digital cameras are identical to film cameras, a few things are slightly tweaked from film expectations, and a number of features are unique to digital photography. Some of the big differences can actually help you take better pictures than you ever did with a film camera (true!).

Just so we keep our photographic perspective, let's first look at the similarities between film and digital cameras. All cameras have lenses. You'll find fixed-focal-length and zoom lenses available for film and digital cameras. The lenses are often considerably different in

size, but then this has always been true when you change formats, such as going from 35mm to 645 medium-format.

All cameras have viewfinders to help you concentrate on your subjects and compose, though these range from optical to electronic. All have shutter releases, shutter speeds, and f-stops (but you can't necessarily select them on totally automatic cameras of either film or digital design). There are focusing mechanisms, from manual to auto (although really inexpensive cameras can have fixed focus). And you'll find something that holds images and lets you take them from the camera for processing (film or memory cards).

For quality results from any camera, the basics of photography still apply no matter how an image is captured. A tripod is always important if slow shutter speeds are needed and big telephoto lenses are used. Fast shutter speeds remain a key way to stop action, and f-stops continue to affect depth of field. The important parts of a scene still need to have the focus centered on them, and dramatic light always helps make for dramatic photos.

Tip

Try a highly corrected achromatic close-up lens with a lens/filter adapter on advanced digital cameras. This will make the built-in zoom a macro zoom for very sharp close-ups.

Some Important Differences

The "digital" in digital camera has caused even experienced photographers to worry that this new technology will be difficult to master. But consider this: No beginner ever picked up a camera and knew what all the controls did. For the serious photographer, f-stops and shutter speeds were definitely not instinctive.

The good news is that digital cameras include features that really can make photographers better at their craft! Such features include the LCD panel and the white balance controls.

Sensors and Megapixels

All digital cameras use image sensors to capture pictures. A sensor is a light-sensitive electronic "chip" that sits behind the lens (a chip in computer terms is a self-contained microprocessor made up of many circuits). When the camera is turned on, the sensor responds to light and affects the flow of electricity through it, depending on the amount of light hitting its surface. The circuits of the camera examine variations in power and map them to specific points on the chip. These data are then turned into photos.

You'll hear about two types of image sensors: CCD (charge-coupled device) and CMOS (complimentary metal oxide semiconductor). For camera manufacturers, there are certain advantages in the construction of each. The CCD

Digital camera sensors mainly work with an array of color filters over different pixels. The full-color image is interpolated from those varied data. The Foveon sensor relies on unique capabilities of silicon to capture complete color information for each pixel.

Slim Films

CCD and CMOS sensors

Foveon sensor

Courtesy Canon USA, Inc.

chips are easier to make in a consistent manner and used to have a quality edge (not true today), but CMOS sensors require less expensive manufacturing processes. The CMOS chips tend to require less power, whereas CCD sensors have speed advantages; these differences are becoming smaller and smaller, though, as sensor technologies continue to improve. While offering different results, neither type holds an arbitrary advantage for photography. Both work extremely well.

Even if two different cameras have the same kind of sensor, they will typically produce different results. This is largely due to the processing circuits inside each camera. Special processing chips can capture improved color, retain detail within bright areas better, and reduce image noise (seen as grain). This can make it difficult to compare

Tip

Image quality depends on more than a sensor. It is also affected by lens quality and the image processing done inside the camera.

cameras for a variety of reasons. Some differences are subjective, calling to mind the debate over which film brand is better, Kodak or Fuji.

A variation of the CMOS sensor is the Foveon X3 chip. On all other sensors, color is made from special filters that cover the pixels—red, green, and blue—and these filters are mixed in a unique pattern that allows a camera to create full color even though each pixel has only one color associated with it. The Foveon chip uses a sensor with separate layers for each color. In theory, this should allow cleaner color.

There are two things to notice about image sensors that do affect the photography: megapixels and camera processing circuits (or chips). A great misunderstanding is that the megapixel count is the most important indicator of image quality. It actually affects quality only in terms of how big an image can be printed. More is not necessarily better, and other issues, such as color and tonal rendition, can be crucial.

Every image sensor is made up of tiny individual sensors called pixels, and each pixel is capable of capturing information about the brightness and color of the light hitting it. As more pixels get crammed into the sensor, a

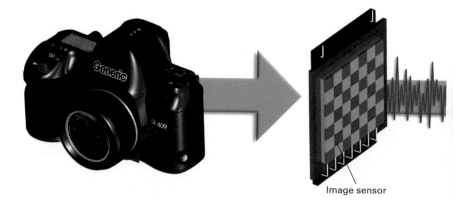

Image sensor

specific set of pixel dimensions is associated with the sensor, such as 3,000 pixels wide by 2,000 pixels high. Multiply the two together and you get an area dimension of pixels. In this example, it would be 6,000,000 pixels, which is the same as 6 megapixels (1 megapixel equals 1,000,000 pixels on a sensor).

With more pixels, you gain two things: the ability to capture finer detail in a scene and the capacity to record smoother gradations in tone. Although you may think that sounds like "quality," you cannot see more than a certain amount of detail in any given print size. Extra detail gives no benefit if it doesn't show up

A 1-megapixel camera is about the minimum needed for photographic quality. It has enough pixels to barely make a photoquality 4x6-inch print. At 3 megapixels, you can easily print true photoquality images to 8x10 and larger. Increased megapixels allow for larger prints. A 6-megapixel

The basic digital camera process is simple: A light-sensitive sensor turns light energy into electrical impulses. This analog signal is interpreted and translated into image data by a processing chip; the data then are recorded on the memory card·

Slim Films

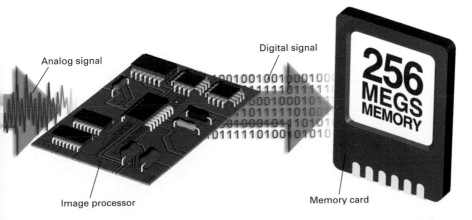

Analog signal

Digital signal

```
0010010010001000
1111011111
0001000101
10111110100
01000101110101
0111110100101010
```

256 MEGS MEMORY

Image processor

Memory card

The LCD monitor or panel helps a photographer see what the lens sees on compact cameras without a through-the-lens viewfinder, and it offers the chance to immediately review photos on all digital cameras.

sensor, however, will not necessarily ensure a better 5x7-inch print than a 3-megapixel sensor, because the 3-megapixel camera has captured enough detail for the 5x7 print.

This is tempered, of course, by the processing of the digital data for the image. All cameras have built-in processing circuits with sophisticated algorithms to get the most from the data coming from the sensor.

As you might expect, less expensive cameras with smaller sensors typically have less sophisticated circuits built into them.

More expensive, higher pixeled cameras frequently have more processing power built into them. This usually results in improved color and

reduced sensor noise. Sensor noise is random data thrown off by the chip for a variety of reasons, and it looks like grain in a photo.

Modern digital cameras control noise very well. But pro cameras generally handle lower light levels and higher ISO settings better than the smaller consumer cameras.

The All-Important LCD Panel

You can often spot a digital camera by the way a photographer stares at the back of it. Nearly all digital cameras have small LCD panels or monitors on the back. These may be replaced by OLED (organic light-emitting diode) panels in the near future. These have revolutionized the way we use a camera for photography. It is like having a Polaroid built into your digital camera. With it, you can verify your composition, exposure, and lighting, and that's just to start. You can also check your subject's expression to be sure you got the best pose. In addition, a digital camera is a great way to break the ice when photographing people. I've sometimes found that people who never liked having their photo taken with a film camera actually enjoyed seeing themselves on the monitor of a digital camera.

In addition, you can review and edit photos as you go. This feature is very freeing for the photographer. You can experiment, trying all sorts of things to discover right away what works for you and your subject. You never have to worry about anyone seeing your failed experiments, because you can trash your bad photos.

Some LCD panels rotate out, up, and down so you can see your image from many angles. This way, you can hold the camera low, high, or anywhere in between and still see what the lens sees. These are known as flip-out LCD panels.

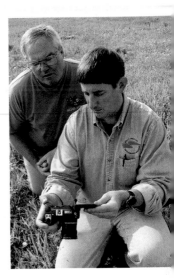

You can quickly tell a digital camera from a distance by the way people look at its back. It is also a way to quickly share what you are seeing with others.

Types of Cameras

Digital cameras come in a variety of forms, from point-and-shoot pocket cameras to advanced digital SLRs. There is no right or wrong type, though a specific one may be best for you and your photography. Let's look at the major types.

Simple point-and-shoot digital cameras can give surprising quality when they have the right lenses and sensors. Because they are totally automatic in focus and exposure, they just have to be pointed at a subject and clicked. They have lim-

Olympus Camedia D-560 point-and-shoot camera

ited capabilities for controlling the image, although even very inexpensive cameras often have white balance controls. Some are exceptionally compact, able to fit easily into a shirt pocket, making them ideal cameras to keep at hand so you won't miss a great photo opportunity.

Advanced point-and-shoot cameras are similar in that they mostly rely on automatic controls; however, this group tends to add special features to make the cameras a little more flexible. Such features include exposure compensation, more white balance controls, limited manual settings, and more. Still relatively inexpensive, these cameras can be a good introduction to digital and are perfect for the families of serious photographers.

Advanced compact cameras have extensive photographic controls, making them much like good 35mm cameras, except they do not have through-the-

Canon PowerShot G5 advanced compact

lens viewfinders (LCD panels provide equivalent views) and interchangeable lenses. They can be used in point-and-shoot, totally automatic mode, too, if needed. They are larger than most point-and-shoot cameras, and specially designed accessory lenses can usually be added to make them more versatile.

Compact SLR-type digital cameras look a bit like condensed 35mm SLRs. These cameras tend to have zoom lenses with long focal lengths, often giving them excellent telephoto capabilities. They typically offer all the controls of 35mm SLRs, just like advanced compact cameras. They have through-the-lens viewfinders, although these often are electronic (EVFs).

Nikon Coolpix 5700 compact SLR-type

With an EVF, you look into an eyepiece that shows you a magnified, high-quality LCD monitor. This shows you exactly what the sensor is seeing and lets you judge exposure and color, to a degree. In addition, these cameras can be used totally automatically.

Interchangeable-lens, digital SLRs offer all the controls of a 35mm SLR, including lenses that give you a wealth of focal-length possibilities.

FOLLOWING PAGES: To get the most from an advanced compact digital camera, the photographer used a tripod to shoot this scene in Arches National Park.

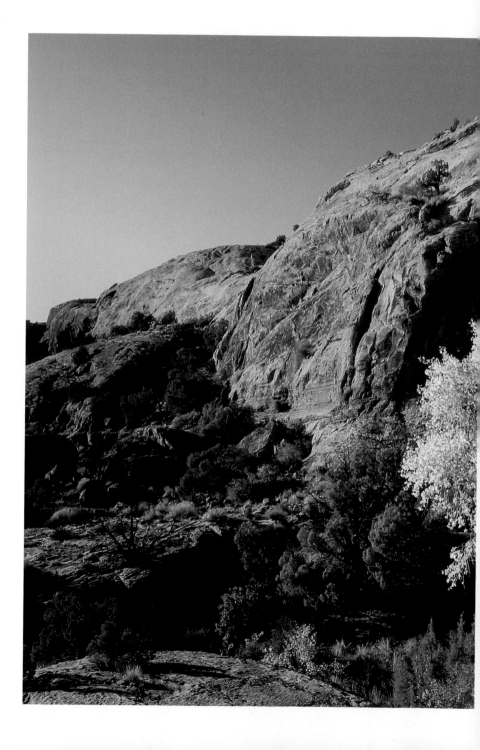

Canon EOS 10D SLR

These cameras are definitely bigger than the other digital cameras. They include complete and extensive photographic controls, the best in image-sensor and processing technology, high levels of noise control, and more. The LCD panel on the back of an SLR can be used only for reviewing images, since the sensor cannot provide "live" images due to the mirror design.

Digital Camera Lenses

A digital camera's sensor, unlike film, does not have to be a specific size. This is one reason why digital cameras can be so small: They are not limited by the dimensions of a 35mm film cassette and the actual picture dimensions of film. Focal lengths of lenses can be confusing because various sizes of sensors affect what each focal length sees in a different way.

This is why when you look at the focal length of a digital camera lens, you should also look for a 35mm equivalent somewhere in the manual or other literature. A tiny pocket digital camera can have an extremely short focal length, such as 6-18mm, unheard of in a 35mm SLR, yet it might be equivalent to perhaps

38-114mm in that larger, well-known format.

Even most 35mm-style digital SLRs have a smaller sensor size than 35mm film. So, there is a multiplier effect with these sensors, magnifying the effect of all lenses (usually a factor of approximately 1.5x). A 300mm f/2.8 lens, for example, suddenly offers the equivalent magnification of a 450mm f/2.8 lens at a fraction of the cost, size, and weight of the latter. This is a great boon for sports and wildlife photographers.

Because digital camera sensors are typically much smaller than 35mm film, wide-angle focal lengths are more difficult. Most cameras with built-in lenses rarely go beyond a moderate wide-angle view of a subject (35-38mm equivalent in 35mm film terms). You will need an accessory wide-angle converter for wider angles (these work very well). With interchangeable-lens cameras, the multiplier effect makes wide-angle lenses about half as wide. So, a 24mm lens acts more like a 35mm lens.

Today we are seeing new interchangeable-lens digital SLRs with "full-frame" sensors sized identically with 35mm film. These allow you to gain the whole focal-length range of traditional 35mm lenses. Obviously, they have a strong benefit in the ability to use wide-angle lenses at their full potential; however, you lose the great magnifying effect with telephoto lenses.

You will hear a lot about digital zoom with point-and-shoot and compact cameras. Depending on the megapixel size of the camera, this feature may not be as useful as the hype implies. Digital zoom simply crops into the center of the sensor to magnify the size of the subject. Then the camera uses special processing algorithms to increase or interpolate the file size to match the normal output size of the camera.

If you have enough pixels, digital zoom can

Tip

To compare digital camera lenses, look for the 35mm equivalent size. The actual focal length can be misleading because sensor sizes are different.

come in handy when you just can't get close enough to a subject. This interpolation, however, is sometimes called "empty" magnification. If you have a stronger telephoto or can get closer to your subject and use the whole sensor area, you will get more detail in the image than a digital zoom can capture. Digital zoom photos can look softer and less crisp than regular photos. It is worth trying if there is no other alternative, but the best bet is to leave it turned off until you really figure you need it.

Speed

Compared with film cameras, digital cameras have several speed issues that can challenge a photographer: boot-up time, shutter lag, and record time. Boot-up time is how long it takes a camera to be ready to shoot after you turn it on. Film cameras have no boot-up time: They are either on or off.

If you have a digital camera with a longer boot-up time be sure you have it on at all times when shooting during changing action.

Shutter lag is something all manufacturers are working to change, and it might not be a significant issue in the future. With shutter lag, the camera takes the picture a fraction of a second after the shutter is pressed. Digital cameras have special needs for autofocus, autoexposure, and sensor readiness, all of which slow down the camera response.

Lag time is negligible to nonexistent in 35mm-style digital SLRs; however, it can be quite significant in other cameras. There is no way to eliminate it, but you can reduce its effect by "prefocusing"—pressing down the shutter to focus and lock focus before pushing further to actually take the picture. With practice, you can

also learn to anticipate the delay and press the shutter just before peak action.

Record time with a film camera is very quick, influenced mainly by how fast you can wind the film (either manually or with a motor drive). With a digital camera, this is complicated by the challenge of moving large amounts of data from

the sensor to the processing chip to memory. Bigger files (for example, more megapixels or larger file formats) take more time to get to the camera's memory card, slowing down the operation of the camera.

High-end cameras typically have special memory (a buffer) built into them to provide a holding place for data waiting to be put on the memory card. Faster memory cards can speed this up, but only if cameras can support those speeds. Lower priced cameras rarely can, so a higher speed memory card does little for them.

Digital cameras vary considerably in their ability to deal with action. For sports and other fast-paced action, the interchangeable-lens, digital SLR will capture the speed of play with no discernible delay from shutter lag.

For most photographers, macro photography was once limited mainly to the 35mm SLR. This photo was shot with an advanced compact digital camera that focused very closely without accessories.

Do You Need a Digital SLR?

The ultimate photographic machine has long been the 35mm SLR with its high degree of photographic control and interchangeable lenses. This has been the camera of choice for most photojournalists and pros such as those working for NATIONAL GEOGRAPHIC.

Many photographers have chosen not to get going in digital photography until they can afford to buy one of the expensive digital SLRs. This may be a mistake because of the increased quality of advanced compact cameras.

The interchangeable-lens digital SLR does offer a photographer several important features, including lens choice, no appreciable shutter lag, more noise control, bigger sensors, and faster operation. But advanced compact cameras also offer advantages: Image quality is nearly identical

when megapixel sizes are similar and moderate ISO settings are chosen, camera size and weight are much smaller, and prices are lower.

One great advantage of these little cameras is their live LCD, meaning you can see the exposure and color of your shot as you take it. In addition, the LCD as viewfinder is easier to use for awkward, yet creative, photography where a camera has to be positioned in a spot where the viewfinder is hard to access. With rotating LCDs, this is even better—no lying on the ground for low-angle shots, for example.

I use both types of cameras for serious photography. I do not want to give up the size and fun of my compact digital camera, and I want the flexibility of lenses and quick response of my digital SLR. If you can afford only one, you might start with the less expensive advanced compact camera. Treat the camera with respect and care, and employ your photographic craft just as you would with any high-end equipment; your reward will be great images and a lot of fun.

The right photo captures the same violets shown in the standard photo on the left, but it was shot by a camera with a rotating, live LCD panel. Because the panel could be rotated to allow the photographer to see the image, the camera could be placed low, among the rocks.

Image Size and File Formats

Most cameras give you a choice of file format. Because the choice you make affects image quality, speed of use, storage space, and more, this is an important decision. You will have choices in resolution, but always select the highest. That's what you paid for, after all!

The basic image formats are TIFF, JPEG, and RAW. Tagged Image File Format (TIFF) is an important working format in the computer because it provides very high quality from your image and is rather ubiquitous among programs that can use photos. It isn't used much anymore as a camera format, however, because it occupies a lot of storage space and takes forever to save and open for review on the camera.

The very popular Joint Photographic Experts Group (JPEG) format is common to just about every digital camera on the market. A highly engineered compression format, JPEG smartly reduces the size of all the image data coming from the sensor and processor so that the image file can fit into a smaller file. It does this by looking for redundant data and by mapping things like color to large areas rather than remembering the color for every pixel. It is also a variable compression format, since the amount of compression can be changed.

JPEG processing determines what excess data can be thrown out and rebuilt later. With low levels of compression (10:1 or less, for example—the highest quality JPEG settings), this loss is minimal and will have little or no effect on a photo. At high levels of compression (say, 20:1—the lower quality settings), the files get much smaller, but the thrown-out data can be missed when the photo is rebuilt from the file, meaning quality can be lost. When shoot-

ing, always use the highest quality JPEG settings.

The great advantages of JPEG are speed and storage space. But once a JPEG file is in a computer, it should be converted to TIFF or the native format of the image-processing program. The reason for this is that every time a JPEG file is opened and saved, data are thrown out and rebuilt, so the file starts to degrade.

The third format is RAW, a proprietary image file that captures "raw" data from the camera's sensor. Although manufacturers sometimes hype this as image data without processing, technically this is not true. All image data coming off the sensor chip must be adjusted somewhat; at a minimum this involves converting the steady flow of electrons from the sensor (analog data) into digital information properly formatted for saving to the sensor. RAW data, however, are closer to the original information coming from the chip, are not processed by any special camera algorithms, and hold potentially more color and exposure data than JPEG or TIFF.

As a result, RAW can give very high image quality, which can be quite significant when you need to make large prints or must deal with an image that has a lot of fine tonalities in the light and dark areas.

Although smaller than TIFF files, RAW files are larger than JPEG files. RAW files use more space on memory cards and the camera slows down (it must deal with more data per image for storage and playback). RAW files also demand a slightly more complicated workflow.

You are unlikely to see a major difference between RAW and JPEG files when images are well exposed in good light, when prints are small, and when images of any size are reproduced on newsprint. Where RAW can be worth the effort is when shooting conditions are tough,

Tip

JPEG is a great shooting format, but you should not use it as a working format in the computer. Always resave your images in TIFF or in your image processor's file formats.

when you need the ultimate in quality for the big print, and when you have the inclination to deal with the added workflow needs of the format.

Batteries

Without batteries, most modern cameras, film or digital, cease to function. The challenge with digital cameras is that everything, from the LCD panel to autofocus to sensor operation, requires battery power. Consequently, batteries are used up quickly.

There are several things you can do to make battery usage less of an issue. To start, if your camera uses AA batteries, never use plain alkalines. Use nickel metal hydride (NiMH) rechargeables for most purposes, and always keep lithium AA's for backup and travel; the latter cost more but they last five times as long and are very lightweight and dependable.

Many cameras have proprietary lithium ion (Li-ion) rechargeable batteries, which work great and are custom sized for use in your camera. You should always have spares; they are critical for digital camera use. Two sets are a minimum, and three can be extremely helpful. With three sets, you can go out shooting with a fresh set in your camera, another in your camera bag, and the last set on the charger so it will be ready to go when you return.

Memory Cards

In most digital cameras, images are stored on memory cards, removable storage devices that hold images and make them easy to transfer to a computer. Extra cards should be a first purchase after buying a camera. Unless you have a very simple camera with a small sensor you may want to consider 256 MB and larger cards.

The most common card in use today is the CompactFlash (it refers to flash memory and has nothing to do with photographic flash). This card is extremely durable (like many photographers, I accidentally put one through the washer with no ill effect) and comes in very large sizes. Special, high-speed cards are available for the photographers who need them.

Hitachi/IBM makes a special CompactFlash-size card called the Microdrive, which offers low prices for very large storage. It is, however, far more sensitive to mishandling.

A few manufacturers use SmartMedia, a thin but fragile, fast card. The Memory Stick, Sony's proprietary approach to memory cards, is about the size of a stick of gum. SD or multimedia cards are much smaller than any of the first mentioned and were originally developed for MPEG players. XD media is the smallest yet.

Memory cards come in a variety of types that fit specific cameras. The most common is the CompactFlash card. Consider buying at least a 256 MB card, because larger cards give you more photographic flexibility.

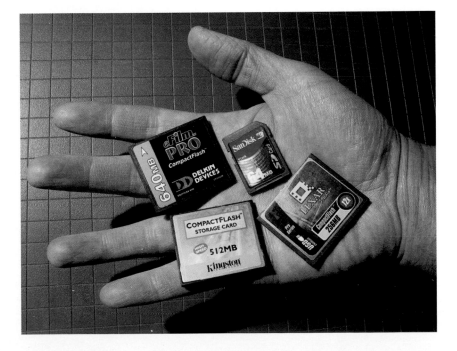

Shoot It Right From the Start

THE WAY TO GET THE BEST PHOTOS from a digital camera is to do it right from the start. Yet there is an idea that one doesn't need to devote much effort when you have the computer to "help."

This idea has sometimes reached almost surreal proportions. A couple of years ago, a digital photography article in a major news magazine said software was available that would automatically transform amateurs' photos into images that would rival the best of pros. That software never existed, nor will it, because good photography has always been about art and craft; about understanding the tools of the craft and using them well; and about perception and the ability to capture an image that catches an audience's attention and communicates well.

Just remember that digital photography is still photography.

Exposure—Something Old and Something New

Exposure is probably one of the most basic elements of a photographer's craft. Camera manufacturers today have designed remarkable exposure systems into cameras, ensuring at least good exposures for most images. But one challenge you will face with a digital camera is that, like film, it is still sensitive to the right exposure.

Use the LCD panel to check the bright and dark areas of your image to see what details are or aren't there. Use the LCD review to help make your autoexposure work better. You can adjust exposure of the next picture even on a simple camera. The LCD lets you learn this much faster, because you don't need to wait to have your film processed.

For ultimate exposure evaluation, many manufacturers of advanced compact cameras and interchangeable-lens digital SLRs have added a

Good photography is always about recognizing and responding to the subject, not about the computer. That means shooting the right way from the start, no matter what camera you use.

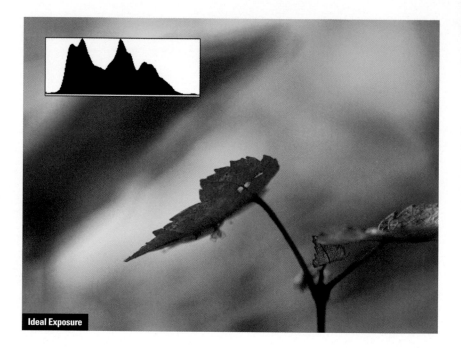

Ideal Exposure

histogram function to the camera's features. A histogram can look a little complicated at first, but reading it is really pretty simple.

The histogram appears as a chart that looks like a hill or mountain range, with slopes at the left and right. To read exposure, you need to look at the left (shadow) and right (highlight) parts of the chart. A low-contrast scene will hold the entire "hill" of data well within the left and right borders. A high-contrast scene will use up the entire area of the chart.

Underexposure will register as no or little data on the right side of the chart (no values are charted), and often the hill at the left will be cut off sharply at the far left edge. Overexposure is the opposite, with little or no data on the left side of the chart compared with the right, and the right side will be cut off sharply. With really high-contrast light, you could find a histogram that cuts off at both right and left sides of the chart.

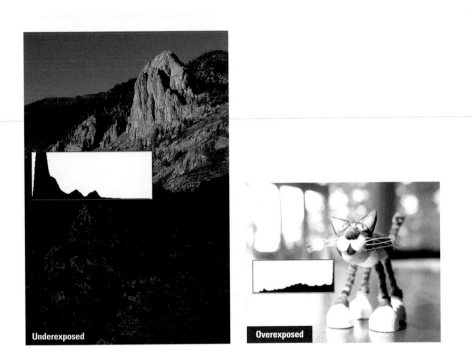

Underexposed

Overexposed

The histogram is worth learning, because it can help you be certain an exposure is correct. A good exposure keeps important shadow detail on the left and the highlight information on the right; it does not cut off key data.

You want a histogram that slopes down as close as possible to the most important brightness values of your photograph. If the highlights are critical, then the slope must end at or before the right side. If the shadows are most important, then the slope must favor the left side. This can be very important in getting an image with proper data going into your computer.

None of this is absolute, and the histogram must be interpreted with your ideas of what makes a good photograph. Try different exposures and see what they look like on the histogram so you can learn how this function reads different scenes. Once you can use it, you will find it a valuable resource.

White Balance—a New Era for Color

White balance is a wonderful new digital control. It adds a new level of management for color that is not easily duplicated in film photography. White balance controls the response of the camera to the color of light so that white and other neutral colors can be recorded as neutral.

Color of light is measured on the Kelvin scale, with low numbers warmer in tone than high numbers. Incandescent lights are typically under 3000K, daylight is around 5,500K, and light in open shade often reaches 10,000K. If you photographed each with daylight film, the incandescent light would look orange, the shade blue.

White balance corrects images to make nearly any light look neutral as needed. This is a huge benefit for photographers. For example, when photographing under fluorescent lights you had to filter carefully, sometimes using expensive color-temperature meters. Often, photos taken under fluorescent lights looked a sickly green.

Enter the digital camera with white balance controls. Now that photo you took under fluorescents actually resembles what your eyes saw.

White balance is typically controlled in three ways: automatic, with presets, and custom. Let's look at all three types of white balance control.

Automatic white balance for most cameras works well much of the time, though I wouldn't say it always provides the best color rendering.

With the camera on auto white balance, it actually looks at the image and figures out what would make white neutral. Often this works perfectly, but sometimes it misses badly.

A definite problem with automatic white balance also comes from shooting in light we expect to be strongly colored, such as at sunrise or sunset. We are used to seeing these times of

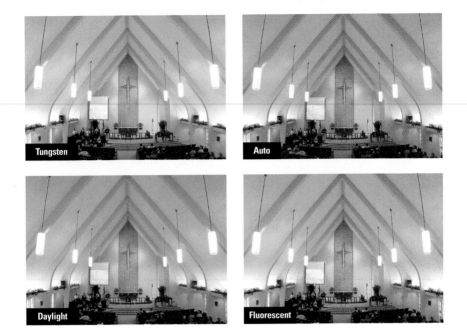

White balance offers new possibilities for a digital photographer. As seen here, various choices give different results, all of which could be used for the scene. The "right" setting will depend on the needs of the photographer.

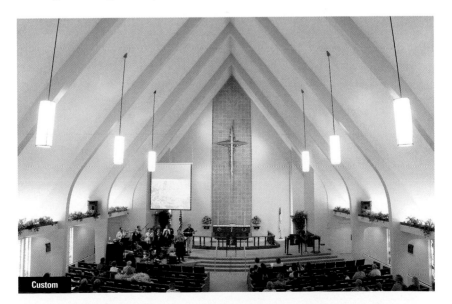

day look very warm. Automatic white balance will usually remove much of that warmth, trying to make the light more neutral.

White balance presets are easy-to-use settings designed for specific light. They lock the white balance to that condition, even though you can use them for other conditions.

Daylight is like daylight film and is designed to correct neutral colors under the conditions and color temperature of midday sun. Cloudy warms cooler light, much like a warming filter added to daylight slide film. Because of this, many photographers regularly set their white balance to cloudy to ensure a warmer color balance. This setting will not only intensify the warmth of sunrise and sunset but also help rainy-day shots look more inviting.

Incandescent, like tungsten film, is designed to correct indoor conditions under standard tungsten lights, and as a result, colors are truer to what we see. Fluorescent adjusts to the fluorescent lighting so common in modern office buildings and stores. It takes the green out.

Flash is designed to compensate for the slightly cooler tone of flash, making it look more natural and without the blue that can make skin tones appear harsh and unattractive.

You can try any of these settings at any time. Try them under different conditions, and you may like the results. There is no right or wrong; they are simply different responses to light.

Custom or manual settings have long been part of the professional video world. News videographers place something white in a scene and zoom in until it fills the designated area. The camera does its white balance magic on the object, turning it white for resulting images and saving that setting. You use the same basic technique for digital cameras.

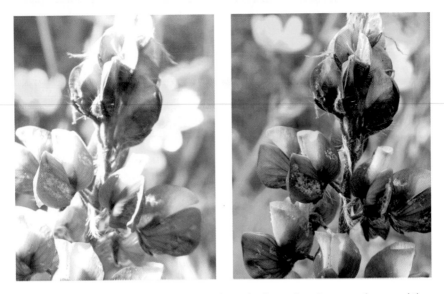

Seeking a natural look for the flash on these lupines, the photographer used the monitor on the back of the camera to confirm that the exposure was correct and the light was coming from the right angle.

Flash

Flash has long been something photographers wished they understood better, and it can be a source of worry when using film because you can't see results until long after taking a picture. As great as automated flash is today, the results can be difficult to predict without a lot of experience. Many photographers simply don't use it.

That's too bad since flash is such an important tool and has been used increasingly by photographers wanting their images to have a special look, even during the day. With digital cameras and their LCD review, you now have the ability to quickly harness the power of flash. You can take a shot, look at the results immediately, and make adjustments to get the flash how you want it.

Digital Grain

Grain is part of photography. Photographers usually want to get rid of it, but sometimes it is used for creative effects. Grain comes from the qualities of the film and its processing.

Digital photography, unlike film, potentially has no grain; however, digital noise has an effect that essentially looks like grain. It is affected both at the time of shooting and in the digital darkroom. The cause in the camera is sensor noise. For photographers, it is very important to know why noise happens and how to control it:

1. High ISO settings increase noise. When sensor sensitivity is enhanced, noise is also increased. This is similar to film, where a higher ISO can result in more grain in the film. When possible, use lower numbers such as 50, 100.

2. Long exposures increase noise. Early digital cameras really suffered in this area and could not take pictures with shutter speeds even a second or longer without horrible noise appearing. Modern sensors have controlled this greatly, although exposures longer than a second will typically increase grain effects.

3. Digital challenges due to lower megapixels can create digital grain effects. Simply put, a sensor has a finite number of pixels to cover infinite gradations of tone, which are especially noticeable in the sky. With fewer pixels available in lower megapixel chips, the camera has to interpret the sky in ways that can lead to what looks like grain.

4. Higher levels of JPEG compression can give the appearance of grain. This can be very apparent in large, smooth-toned areas like sky. JPEG throws out data in blocks. With greater compression, these blocks start becoming more

Tip

Low light will increase digital grain. Use a flash or other added light if grain could be a problem and must be kept to a minimum.

noticeable and can create grainlike patterns in smooth areas.

5. Enlargement increases grain. This is true with film and digital photography.

Of course, grain can be a creative part of photography, making images look more gritty and journalistic (like the work of early newspaper photojournalists) or abstract and ethereal. Then you can use the ideas above to increase grain.

Digital cameras make scenes look good in all sorts of light, but indoor light levels can lead to higher ISO settings and other factors that increase the appearance of noise (or digital grain).

FOLLOWING PAGES: Digital SLRs have interchangeable lenses to allow long telephotos for wildlife photographs; they also have larger sensors, which are less prone to noise or digital grain, even at higher ISO equivalent settings.

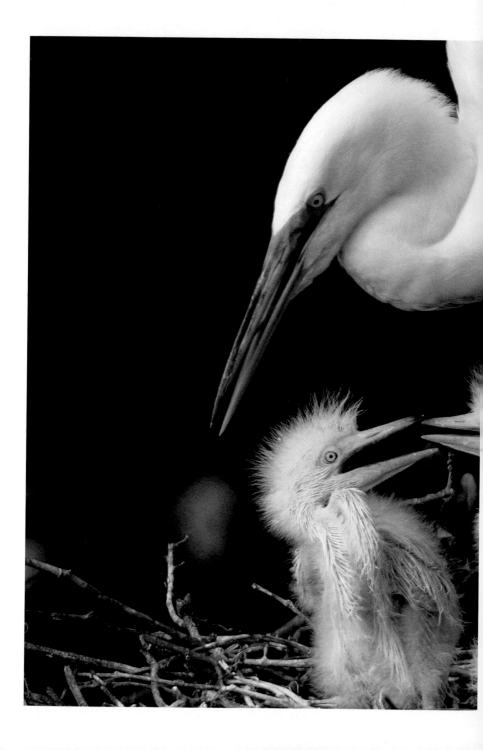

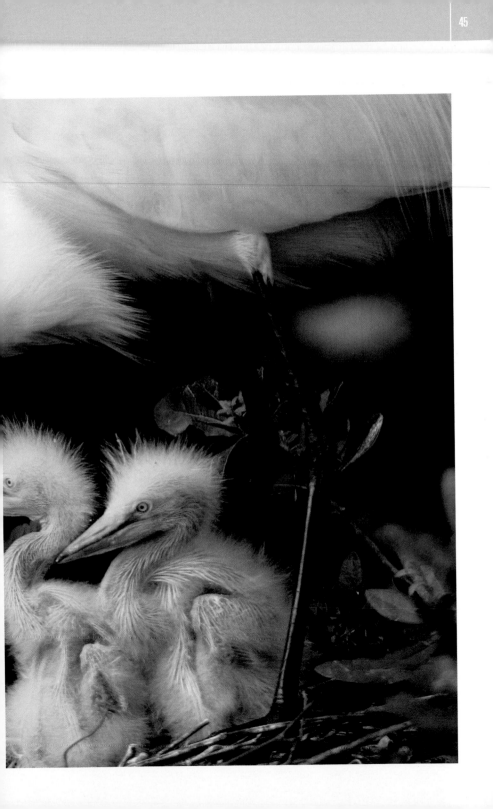

Black-and-White Photography

This book is mainly about color, but black-and-white photography has made a strong comeback in popularity. It is definitely a different way of dealing with images of the world: Black-and-white can offer new and dramatic looks at familiar subjects. You must learn to ignore color and look for tones of gray.

The digital camera makes it easier than ever to shoot black-and-white photos, because it can quickly show you how scenes translate into tones of gray. On most compact and point-and-shoot cameras, you simply choose a black-and-white setting, and the scene instantly appears on your LCD monitor in black and white! You can directly compare what you see in the real world with the tones of gray on the LCD. This will help you look for the tonal contrasts that will shape your composition, and it is a superb way to learn black-and-white photography in a hurry. No more shooting film to be developed later. You know your results right now.

Unfortunately, this is not true for digital SLRs. For whatever reason, the manufacturers decided owners of these cameras wouldn't want to shoot in black and white. It is true that you can change color images to black-and-white ones later, but if you aren't used to "seeing" in black and white, you won't necessarily find it easy to shoot in color without the black-and-white reference. However, there are advantages to shooting in color for black and white, because, for example, the digital darkroom lets you fine-tune your "filtration" to translate different colors into varied tonalities and you can get the effect of using multiple filters (such as green for foliage and red for sky) on the same scene.

Black-and-white photography has many possibilities with digital cameras. A scene can be shot directly in black and white with the camera or it can be captured in color and later changed in the digital darkroom.

Two-Exposure Exposure

A challenge always faced by photographers is dealing with a scene that has a wider range of brightness than the film can handle. This is no different with a digital camera. The sensor is capable of handling only so much of a range from shadow to highlight at any given exposure.

An interesting technique to compensate for this limitation is to lock the camera on a tripod and shoot two exposures of a scene—one for the shadows, one for the highlights (actually, you can go further and take even more exposures for very high contrast scenes). For example, you photograph a sunlit, rushing river with lots of white water, yet the surrounding woods are dark and shaded. You would then take two pictures, one favoring the detail in the white parts of the river (so it doesn't get washed out) and one emphasizing the darker woods (which would wash out the water).

Later you bring the images into the digital darkroom to combine the dark and light exposures into one.

Panoramics

The panoramic image has become a wonderful way of communicating about a world full of vistas. This format used to be available only to the photographers who owned special cameras capable of taking wide pictures, but the cameras were expensive and used up film quickly (some film cameras had panoramic settings; however, the images were actually cropped from the full film size, resulting in lower image quality).

Digital photography lets you build a panoramic photo using any camera. You set your camera on a tripod and take several photos

> **Tip**
>
> Use a filter for more control over the digital camera image. The polarizing and graduated neutral density filters are especially helpful and should be in your camera bag.

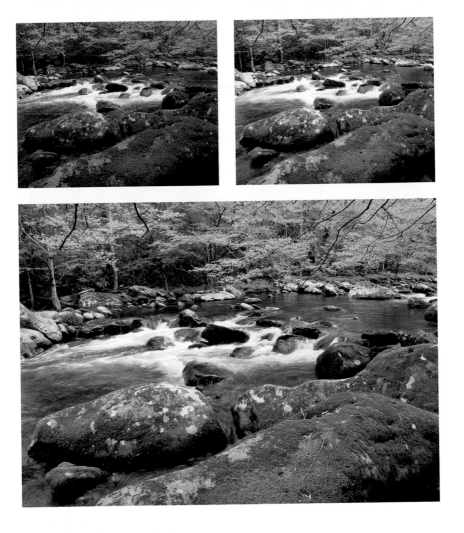

overlapping the scene. Digital cameras make this very easy to do, because you can compare each shot as you go to be sure you get the overlap right. Some cameras even include panoramic helps (such as the previous shot ghosted over the LCD panel to help you line up the shots). Later you can put the photos together with automated panoramic software that actually works quite well.

The top left photo was exposed for the water highlights, the top right for the darker colors. They were combined in the bottom image for a more accurate rendition of the scene.

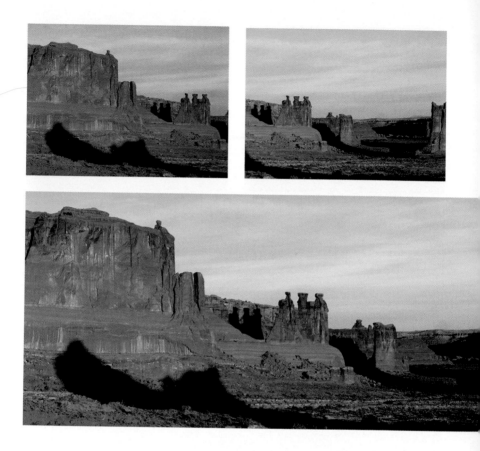

To take panoramic images, you must do several things:

1. Find a scene that works for a panoramic shot. You need to find something interesting from side to side. Look for things that flow and change, with visual elements throughout the area.

2. While wide-angle lenses can be used, they can be a real challenge to put together. You are best off with a lens in the 50mm range or longer.

3. Set your camera on a tripod and determine a manual exposure and white balance so the captured images don't change in color or tonality.

4. Level your camera (it is best to use a bubble level because this will make it easier to line up the

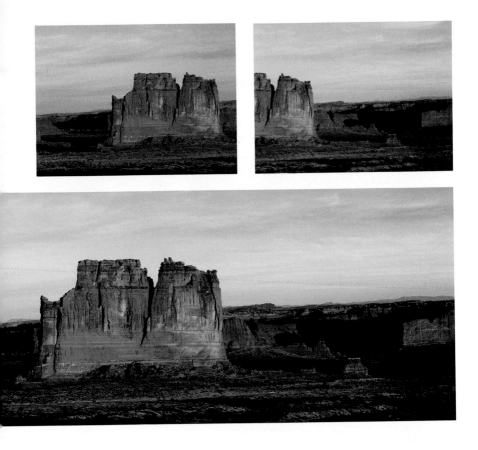

images later). Align the top of the camera with the horizon to see if it is level, and swivel it through the whole panoramic composition to see that it stays level.

5. Start on the left, and find the beginning of your broad composition. Take your first photo.

6. Rotate the camera through the panoramic composition, and take pictures as you go. Overlap each photo by about 30 to 50 percent, and experiment to see what amount of overlap works best for the software you're using. Be very careful to keep the camera steady through the rotation.

7. Later, put the whole thing together in your image-processing program.

By shooting overlapping photos, a photographer can create panoramic photos with any digital camera and automated panoramic stitching software.

JIM BRANDENBURG
Playful Creativity

Courtesy Minden Pictures

JIM BRANDENBURG has shot around the world for NATIONAL GEOGRAPHIC, doing memorable pieces on everything from Japan to wolves. His books, such as *Brother Wolf* and *Chased by the Light*, have been photographic best-sellers. He is considered one of the premier nature photographers in the world, and you would expect him to have "been there, done that" for much of his photography.

But today he talks like a teenager about the excitement he has for photography, largely because he now shoots all digital. "I have become younger, my work fresher," he says. "For me, it has offered a whole new way of seeing. It is exciting because it makes me a better photographer."

Brandenburg didn't start shooting with digital cameras just because he simply wanted to use the technology. He says he was always a strong traditionalist as far as equipment went and was one of the last of the pros to go to autoexposure and autofocus. But with his status as a top pro, he was approached by manufacturers to try out their digital cameras. He figured this would be a short trial and never thought he'd really take to the equipment.

Jim Brandenburg made the transition to shooting mostly with digital cameras in the early 2000s. While trying out the technology as a favor for certain manufacturers, he quickly discovered that digital cameras have great advantages. He

says they not only allow his photography to be closer to what he sees but also help him to be more lyrical and poetic. This is largely because he can use their LCD panels to see and respond instantly to what he is shooting.

He was wrong. It didn't take long for him to love the new technology. "I discovered digital is a more organic and natural way of seeing than film," he says. "It better duplicates the way the human eye sees. You pick up a camera, take a picture, and immediately can react and interact with it. That's not possible with film. Plus, with the newest equipment out there now, it's clearly better than film."

For Brandenburg, the "better" largely refers to how photographers make more effective and expressive photos. He feels this ability

A single strand of pearl-like water drops, in focus, makes this photograph work. In the past, Brandenburg would have shot many versions to be sure he got something. Now he knows what he has right away.

derives from the instant feedback the LCD panel gives; the greater shadow detail possible in an image; and the playfulness digital cameras encourage. "Film was always based, to a degree, on cost, even when as a pro, you weren't paying for the film," he explains. "There was a psychological issue; you knew you had to change rolls of film, that they each cost something, and you'd have to edit it all later. Being somewhat frugal myself, I didn't want to feel like I was wasting film.

"Digital changes all that. There are no worries about wasting film. This means you can take chances you wouldn't have taken in the past, so you play and experiment freely. Couple that with the instant feedback of the camera, and you have a whole new way of seeing. I believe digital will change photography, and we haven't even begun to see all of its effects."

But Brandenburg also sees a possible downside to this technology: "It makes experimenting and trying new things so easy that it scares me to think about what young people might do. As photographers, we all have to take this ease and put new efforts into creativity."

Brandenburg says that although there are more serious challenges to working with digital, such as editing images and keeping track of them, he feels these are minor and that he will get used to them. For him, digital has made all the difference in taking his photography to new levels, as can be seen in his latest book, *Looking for the Summer*.

A magical photo inside the color of a flower—how else can one explain such an image? A photo like this starts as an experiment, something that is greatly encouraged by digital photography.

Transferring Digital Images

DIGITAL CAMERAS TODAY come with some way of transferring the photos to the computer. This usually involves some sort of cable, although some cameras are using infrared and other wireless technologies. Direct connection may not be the best way for photographers to get photos onto the computer's hard drive, however. Many people find a card reader much more convenient. Let's look at both methods.

When you use your camera for downloading, you simply hook the correct cord to the proper port on the computer and the right spot on the camera. USB connections are very common and quite easy to use. FireWire is starting to show up regularly on computers and is very, very fast.

Depending on the camera and its software, you may next find a program loading to help you move photos onto the hard drive. At this point, nothing is happening to the digital image files other than being copied from one place to another. However, you do need to pay attention to where these files are going as this is one spot people often have trouble with—the files end up somewhere on the hard drive, but where?

A faster and simpler way of transferring images, is a card reader, a small, stand-alone device that you plug into the computer with a slot for your camera's memory card. You can get readers dedicated to only one memory card type

394

600 |800 |1000 |1200 |1400 |1600 |1800 |2000 |2200 |2400 |2600 |2800 |3000 |3200 |3400 |3600 |3800 |4000 |4200 |4400 |4600 |4800 |5000 |5200 |5400 |5600

or others that will read them all. You may need
to install a driver for this reader.

The card reader is easy to use and very
affordable. You simply take your memory card
out of the camera and put it into the slot. The
computer will now recognize the card as a new
drive. You can go through your computer's file
system just as you would any other files, select
all the photos and copy them to a new folder.
It is a good idea to set up this folder ahead
of time so you know where to put the images

If you do not have a
digital camera, you can
still benefit from the
tools of digital photog-
raphy. You can digitize
slides, negatives, or
prints with a scanner.
This shows the inter-
face for a film scanner
and displays an image
preview of a slide.

(plus this makes it easier to keep them straight).

A variation of this comes with the transfer of images to laptops and PDA's (both of which work very well to hold or review images). A few laptops and most PDA's actually have slots for memory cards. Transfer of images from direct slots can be very, very fast.

Most laptops have PC card slots, which are used for everything from wireless modems to increased storage. You can get memory card adapters that fit into these PC card slots. Plug one in and you'll find transfer of images goes blazingly fast. If your slot is filled, you can still use USB or FireWire card readers.

You can easily transfer your digital photographs directly from the camera (below) or from a card reader (right). You simply take the memory card from the camera and put it into the card reader for fast and simple image transfer.

Dazzle memory card reader

Olympus camera direct connection to computer

Handheld Storage for Field Use

You're not going to be carrying around a computer all the time, so how can you download images as you go? You could keep a lot of memory cards with you or buy some very big cards. But if you are traveling, sooner or later you will run out of storage space.

There are two basic solutions for this:
1. Small laptops or
2. Handheld digital storage devices.

Small laptops can be a good solution for the working photographer there are some who has the space for one. There are some especially rugged units on the market that are designed to take abuse in the field, yet weigh no more than a couple of pounds. Any laptop's advantage is being able to view and sort images on the nicely sized screen.

For sheer compactness, the handheld digital storage devices can't be beat. They come with names like Nixvue and Digibin. They are basically a small, portable, and battery-powered hard drive in a case with a card reader and direct circuits connecting them. You simply plug in your memory card and the images are transferred quickly to the hard drive.

Tip

Keep a memory card reader attached to your computer for quick and easy downloads at any time.

EZDigiMagic portable CD writer

With portable storage devices, you can download images from your memory card as you go along. This portable CD burner preserves photos on CDs.

You can set up folders to help keep groups of images separate, and the latest of these devices include a small LCD screen to allow you to see the images. These units will fit into a gadget bag so they are easy to always have with you. You do have to be careful with them, since they are hard drives that can be damaged if dropped. Some portable CD burners are available that allow you to transfer images to a CD in the field.

Photojournalists have an additional task. They need to get an image back to an editor immediately. They will transfer images either to a laptop with cellular modem or a PDA with wireless capabilities. Then with a little help from the communication or e-mail program and processing power of the unit, they send the images off instantly.

Such technology has been a huge benefit for newspapers and news-oriented web sites who can now compete with television in showing off the latest visuals from a newsworthy event.

Gateway laptop

Kanguru mini hard drive card reader

Archos Jukebox card reader and mini hard drive

When You Shoot Film—Scanning

You can still join the digital revolution if you shoot film. There is just an added step involved to get the photos (slides, negatives, and prints) translated into digital data so they can be used in the computer. That, of course, is scanning.

Like everything else we've been discussing, scanning is a craft, and practice does make for better scans. Although an extensive look at scanning is beyond the scope of this book, I will help you get started and learn the basics of choosing and using a scanner.

Selecting the Right Scanner

Scanners come in two basic types, flatbeds and film scanners. The differences between them used to be clear—flatbeds were for prints, film scanners for slides and negatives. This difference is no longer so clearly defined. Newer, high-resolution flatbeds are capable of excellent scans of both slides and negatives as well as prints.

A flatbed scanner is, as the name implies, a flat unit with a lid that opens to reveal a piece of glass where the photo, slide, or negative to be scanned is placed.

A film scanner is generally blocky looking with an opening to insert slides or negatives. It takes up less space on the desktop. Film scanners do a great job with both slides and negatives.

All scanners work by illuminating the photograph. A flatbed's imaging sensor then reads how the light is reflected off the print. Film scanners

Many devices, from laptops to stand-alone hard drives, are available for downloading images when traveling. They let you unload your memory cards so you can keep shooting without limitations.

and flatbeds with transparency adapters read the light being transmitted through the film. The sensor has a set of pixels to identify the details of the image, then the scanner and computer translate the data.

Resolution is a key feature to consider with a scanner. It is a direct function of the number of pixels available on the image sensor. It is not, contrary to popular opinion, the defining characteristic of scanner quality. It primarily affects how big you can scan something—more resolution means a bigger image file from the original.

You need a certain amount of pixels available in an image file in order to make a print of a certain size. This is a critical issue for scanning film. You must have a high resolution for scanning the small image area of 35mm because you need all the pixels required for a big print (say 8x10 inches), crammed into that area. This is why you rarely see film scanners with resolutions of less than 2,400 dpi (dots per inch). This would result in 2,400 pixels along the short, one-inch side of 35mm film, which could be expanded to an 8x10-inch print if it were changed to a common image resolution of 300 ppi (pixels per inch but often referred to as dpi, too).

Keep these guidelines in mind for all scanners: For scanning prints, 1,200 dpi can easily scan 4x6-inch prints and larger and allow you to make big prints (16x20 inches). For medium- and large-format transparencies and negatives, 1,200-1,600 dpi will give you good-size prints. For 35mm slides and negatives, you need at least 2,400 dpi.

Some flatbed scanners give their scanning resolution with two numbers, such as 1,200x3,600. The first number is the optical scanning pixels and the more important. The

second is a "stepping" number that describes how the sensor steps across the image as it scans. You may also see "enhanced resolution" or other names for that interpolation. This is software-produced resolution and does not accurately capture image detail like optical resolution does.

Density range—how a scanner handles the density of an image, or the tonal detail from black to white with all the grays in between, is a very important part of scanning and can have a substantial influence on image quality. However, higher density range capability (the range is called Dmax) is a harder thing for manufacturers to build into a scanner.

The higher the Dmax number, the better, up to a point. The maximum range (found in slide film) is 4.0, so higher numbers tend to be both

Scanning offers additional possibilities with digital photography. It lets you digitize new and old images shot on film, such as this nearly 20-year-old monarch butterfly slide, for work in the digital darkroom.

theoretical and marketing hype. Also, the numbers are not linear. A rating of 3.2 seems close to 3.4, yet this is a logarithmic scale, so each tenth is actually a factor of 10.

Slides and transparencies need scanners with the most density range because they hold such a range of detail, from the clear parts of the film to the darkest areas. For detailed scans of slides, look for a Dmax of 3.4 to 3.6 and higher.

Negatives need less since the orange mask of the film lowers the actual density of the film. Scanners with a Dmax above 3.2 are sufficient. Prints also have lower density range needs and can work quite well in the 3.2 and higher range.

Speed is a major price issue with scanners. Lower priced scanners are typically slower (although high-resolution scanners can take longer to scan because they have to deal with more data). If you do a lot of scanning, the added cost can be worth the expense.

Connectivity refers to how a scanner connects to the computer. This affects its speed, its price, and how you use the scanner. Today, there are basically two types of connection: USB and FireWire. USB is more common but FireWire is significantly faster.

Flatbed vs. film scanner—if you are working with prints, the choice is obvious because only flatbeds can do them. However, with film, this choice now comes down to the resolution you need and the density range available. You can find excellent flatbeds that compete with film scanners for doing slides and negatives. For medium-and large-format films, flatbeds are probably the best way to go as you can get very high quality scans with less cost than with dedicated larger film scanners.

Tip

Scan at the highest image resolution (size) that you think you may need from a photo. You can easily resize the image later if you have to make it smaller.

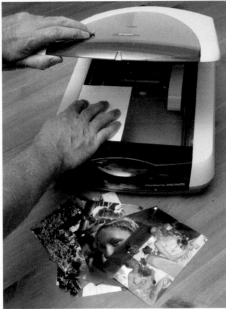

Epson Perfection flatbed scanner

Nikon Coolscan film scanner

Some flatbed scanners (left) can do both prints and film with the right resolution, but they are required for prints. Film scanners (above) are optimized to get the most from slides and negatives.

Scanning Film vs. Prints

If you only have a print of an image, especially likely if you are dealing with old photos, you have no choice. You must scan the print.

However, if you need the best quality from a photo, scan the negative, slide, or transparency if at all possible. The actual film is the first level of quality and has the most sharpness and tonal qualities possible.

This is quite dramatic when you look at print film. A good print will show detail from black to white of a range of 50:1—you could actually see 50 distinct steps in tonal change. On the other hand, the negative typically has a range of 500:1. This shows up in a huge amount of tonal and color detail that is not seen in the straightforward print. Yet it is in the negative and you can retrieve it in the scan.

Scanning Basics

To understand scanning, you need to remember that it is a craft. You will get better with practice. There are some steps to keep in mind that will help you improve your scanning craft:

1. Clean your scanner. Anything you don't clean will show up in your image file and make more work for you later.

2. Clean your film or prints. Dust can be a big problem with film, so be especially careful with it. Clean camel hair brushes (that never touch your skin because oils will get on them), anti-static brushes, compressed air (don't shake the can or propellant can escape and harm your film), and film cleaners are useful accessories to keep by your scanner. Prints can be cleaned with brushes and compressed air.

3. Do a pre-scan. This is basically your test and will tell you how the image will scan with the scanner's basic settings. This is also the time to check to see if resolution settings are correct and to be sure special features, such as Digital ICE (a dust-and scratch-removing control), are on. If the pre-scan looks good, tell the scanner to do the complete scan.

4. If the pre-scan isn't what you want, make adjustments. Some photographers are under the misconception that the scan isn't that important because you can always make adjustments in Photoshop. This is a bad habit to get into for two big reasons:

a. Adjustments in software can only be done on image data that have been scanned into the file. The software can't do any better than the scan, yet if more information is in the original image, the scanner can always do better.

b. Adjustments to an image once it is in the computer are adjustments that change pixels

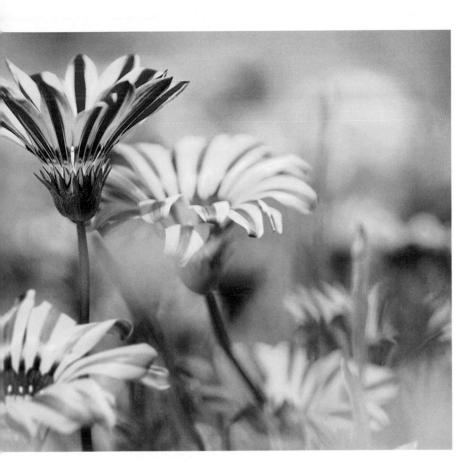

and potentially reduce image quality. Adjustments to the scan affect how the scanner sees the image and translates that "seeing" into pixels, so no pixels are harmed.

5. Look at your scan to be sure it is what you want. Your best scan is an image file that works for your purposes.

6. If your scan is OK, save it.

There are times when you will want to have a lab do your scanning for you. This may be because you don't have time to scan, you need larger, high-quality image files than your scanner can do, or you don't have a scanner.

A good scan requires you to use the scanner's controls to get the most tonal and color detail from the image itself. These details cannot be "fixed" in the digital darkroom if they have not been captured by the scan.

Protecting Your Images

Whether you scan your photos or shoot them
with a digital camera, you now have image data
files that need to be protected. You want to be
sure that you can get your photos when you need
them and that nothing happens to them. It is
heartbreaking to have a whole set of photos on a
hard drive and have the drive crash.

In addition, with digital files, you need to be
sure your files remain pure so they will always
open correctly. This is a very important thing to

Protect your images
by backing them up
outside of your com-
puter. A CD-R, DVD-R,
or DVD+R disk will
save your work if your
hard drive crashes.

think about because photos on a memory card or
a hard drive are on what is called magnetic media
(for the way data are recorded). Data on mag-
netic media fade with time. So it is worth backing
up images in nonmagnetic ways.

One of the best methods consistently used for
backup by photographers is the recordable CD
(or CD-R). This is an optical storage medium
and potentially has a life 50 to 100 years with
quality CD's (look for disks with distinct claims
for archival or long life).

After photographing with a digital camera, you
can immediately make a copy of all unmodified

files to a CD. They become almost like archival negatives. You can always go back to them. Keep this CD in a safe place and make duplicates for very important work.

Rewritable CD's or CD-RW should never be used for image backup and safe storage. CD-RW's are designed to be erased and reused, which means the medium is made to be changed! That is the last thing we need for keeping our important images.

DVD is rapidly becoming another very important optical storage medium. DVD drives usually do CD's as well, but the advantage of DVD is storage space. With a CD, you can get up to approximately 700 MB of data on a CD. With a DVD, you can back up 4.2 gigabytes of data (although disks seem to have a higher "rating").

Finding Photos on the Computer

Finding photos after they are shot has always been a challenge for photographers. Whether a pro dealing with thousands of slides or an amateur facing a shoebox of prints, keeping images straight and accessible is never easy.

Digital technologies don't lessen the challenge, but there are some new possibilities that can make the process easier.

To start, you need a way of viewing images quickly and easily on your monitor. Windows XP has a handy thumbnail view option that will let you see most types of photo files as small images. Go to the appropriate folder in Windows Explorer, then in Views, pick Thumbnails.

While convenient, the Windows XP browser is very limited and does not apply to Mac computers. I think most photographers need an image browsing program such as ACDSee (*www.acdsystems.com*) or CompuPic (*www.compupic.com*).

These programs work on both Windows and Mac (the ACDSee Windows version is more advanced than its Mac version, but this is not true for CompuPic). They do a number of important things:

1. Thumbnails can be resized to fit your needs

2. You can magnify images for review by double-clicking on the thumbnails

3. Programs allow a variety of sorting capabilities (e.g., by date of photography)

4. Images can be dragged to new folders

5. Keyword data can be added to files to make image searches easier

6. Metadata (special file information such as shutter speed and f-stop of digital cameras) of images is shown quickly and easily

7. You can easily print index prints of any or all images in a folder, sized and labeled

These programs allow you to set up a very visual and quite simple filing system. Here's how:

1. Set up a master photo folder on your hard drive. Remember that a hard drive is really an electronic filing cabinet. This master folder could be set up as photos for a given year. You want an easy place to look for photos since all will go in here, whether you have two or two thousand.

2. Make specific folders within the master folder for downloading images from your digital camera. Use names for these folders that make sense to your type of shooting. For example, you could do these by date (Digital Photos March), by trip (Photos Yosemite/August), by event (Dad's Retirement Party), and so on.

3. Using a browser program, check out your photos and delete the images you really don't want. You can also rename all the images in this folder to something that makes more sense than the digital camera's letter/number identification.

4. Print out a set of index pages that show all

Tip

Use an image browser that lets you see all of the photos as thumbnails for quick and easy sorting of digital images. The photos can be quickly deleted, copied, or renamed as needed.

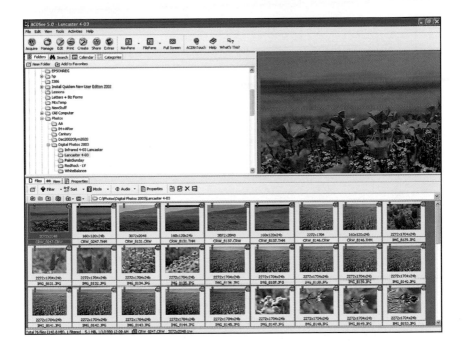

the photos in a folder. Label the page(s) with your folder's name and the image file names. This gives you an excellent visual reference that you can put in a file or notebook.

5. Make a CD-R copy of this folder so you have your photos protected in a backup medium.

6. Make a new master folder called something like Compilations. Then put in subfolders with names appropriate to your photography, like Flowers, Landscapes, Family, and so on. Select photos in their original file folders that fit these categories and copy them to the appropriate compilation file folder. This allows you to build folders of specific topics with duplicate images.

7. Set up subfolders for photos that you have adjusted in the digital darkroom, too.

8. You can also add key words to your files with these browser programs to allow you to search for specific types of images.

Powerful image-browsing programs allow you to look at photos as if they were slides on a light table. You can sort photos by a number of criteria, check single shots as larger images, and set up a filing system for them.

MICHAEL MELFORD
Engaging the Subject

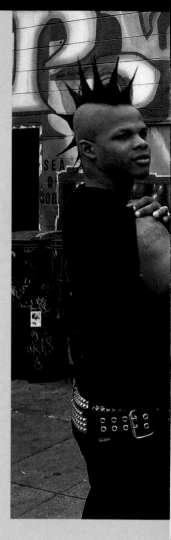

Courtesy Michael Melford

A PHOTOGRAPHER who specializes in taking pictures of people, Michael Melford knows that getting someone to relax and feel comfortable in front of his camera is often a challenge. He has also found that digital cameras help him better interact with all sorts of subjects.

The reason is the instant image displayed on the LCD monitor. Photographers can take pictures and show them to their subjects, who can quickly see that they're not being embarrassed or anything like that. They begin to trust the photographers.

"Strangers who don't know you can be especially reluctant to have their photographs taken," Melford says. "They might let you take one photo if you're persuasive, but then they're done. Now, you take a picture, they see the photo on the back of the camera, and they're ready to do more. They gain confidence in you and get into the process. It becomes a great way of engaging subjects as you photograph them."

Another big advantage of digital is the ability to see right away that you've got the shot. This can be great for average people who aren't used to being photographed. They get tired and impatient with photographers who

Michael Melford is known for his ability to get subjects to relax in front of the camera. He feels the digital camera helps him to do that. These young people in San Diego were initially uneasy and might have allowed only a

few photographs in the past. But with a digital camera's LCD, Melford could show them the results he was getting. The group relaxed and even got into the spirit of the photography.

take a lot of time shooting extra images for protection, something one often had to do when shooting film.

"With film, you had to meter, shoot Polaroids, and bracket like crazy to get the shot," says Melford. "Now you know from the first shot if everything is working. This is especially helpful when you're shooting strobes and mixing light sources. After just one photo, you know what needs to be changed. You do it, and you're done. It's a huge time and stress saver."

A fleeting moment. Did it work? Was it a throwaway? Because Michael Melford was shooting with a digital camera, he knew instantly that the composition and the blurred child (from a slow shutter speed) were what he wanted.

Michael Melford has been working with digital cameras for several years, but the first big professional project that he shot totally with digital was a story on San Diego for *National Geographic Traveler* in the early 2000s. Since working with a medium-format camera was a big part of his professional work, he shot this project with a Contax 645 and a Kodak digital back. Now his digital work is done mainly with a Canon EOS 1Ds. "I shoot a lot of wide-angle views, so having the full-frame 35mm-size sensor of the 1Ds

is important to me," he explains. Most other digital SLRs have smaller sensor sizes so the wide-angle is cropped; you don't get the whole coverage of the lens.

He really got started with the digital process when he took a Photoshop workshop about ten years ago. Still, Melford does not consider himself a computer expert. "It's taken me years to get comfortable with the computer," he says. He adds that he relies on a computer guru, Don Landwherle, for a lot of the technical details.

A street painter in San Diego, this man was also somewhat reluctant to have his photograph taken. When he saw what Melford was trying to do with the image, he worked with the photographer for a powerful portrait.

For Melford, the biggest challenges to digital photography are editing and organizing the photos on the computer, and learning to make the digital images look the way he expects them to look based on his experience with film. "In some ways, digital images are better than film because they have more latitude for tonal details," he says. "But when the photo ends up in a printed piece, I don't always get the results I expect. I find the whole process of printing is hard…it's a learning process for all of us."

Overall, though, Melford finds the technology exciting. He says it makes him feel as if he's discovered photography all over again. "I feel like a kid in a candy store, with new stuff every day," he adds. "And the quality is amazing. The photography is always key; the eye—the photographer's vision—is still very important. But I think my wife is getting annoyed with how much time I spend in front of the computer!"

Tools of the Digital Darkroom

WHEN COMPUTERS FIRST BECAME VISUAL power-houses, they were very expensive. The technology was first used in commercial applications by advertising artists, who tended to do all sorts of wild things with the images.

Consequently, a lot of myths and fears sprang up about computers. It has been said that computers can make great pictures from poor images (they can't); that some software allows amateurs to automatically make photos like pros (not true); that computers remove truth from photography (we have never needed computers to make photos lie); and that film-based photography more closely approximates reality (computers can make images truer to what we see in real life). The list goes on.

What photographers are discovering is that computers are exciting tools, with results much like those of the old darkrooms, and they let you achieve those results in easier, quicker, cheaper, and more effective ways, without the toxic chemicals. Plus, you don't have to shut yourself away in a dark room for hours at a time. The digital darkroom is not about changing the look of the world through funky photos; it's about being able to make photos communicate better. It is not about making bad pictures good; it's about getting the most from good photos in the first place.

One can learn much about what the digital darkroom can do by looking at books from the master black-and-white photographers, such as

Ansel Adams's *The Negative*, *The Print*, and *Examples—the Making of 40 Photographs*. You can also study the work of W. Eugene Smith, one of many photojournalists who made images communicate their best by intensive darkroom work.

Color images actually took photography away from its traditional roots. Black-and-white photographers knew that the straightforward print of a negative was often a misrepresentation of the way we look at the world. When taking a picture, we tend to focus our vision on a single part of a scene,

The digital darkroom offers many possibilities, from journalistic control to fantasy enhancements. Even simple changes, like these of exposure, contrast, and color, can greatly affect an image.

IBM Windows computer

and our peripheral vision only picks up general visual elements around it. But a photograph indiscriminately emphasizes everything in a scene. In the darkroom, masters like Adams and Smith would use things like dodging and burning to control how a viewer looked at a photograph.

When color first became popular, magazine photographers shot slide film. Photographers who tried to make color prints found it a major challenge. Most gave up on the color darkroom as too difficult, too toxic, and not worth the effort. Starting with the logical premise that color printing was hard, this led to the idea that color images couldn't be printed well, which further evolved into the strange idea that color slides were final images of reality that could not be altered.

The digital darkroom changed all this. With a computer, photographers can adjust both color and black-and-white images with more accuracy and control than ever. It is very exciting to make a photo into an evocative statement about the way you see the world. And, the digital darkroom has the potential for handling everything from simple adjustments to elaborate photo-illustrations.

What You Need for a Digital Darkroom

You'll hear a lot about what you do or don't need in terms of computer power for the digital darkroom. Much of this information, although not inaccurate, can be misleading, because almost any good up-to-date computer can be used for photography. There are, however, key features that can make your work easier.

RAM (random access memory) is the number one feature you need for image processing; it is the active memory your computer uses to work on anything. You may gain a second or two by buying the latest and greatest in processing power with your computer, but your working time can be affected a lot more if you don't have enough RAM.

The absolutely bare minimum needed is 128 MB, and a better minimum would be 256 MB. Many photographers use 512 MB or more. Buy as much RAM as you can afford.

Image-processing software, some plug-ins, and a browser program are also necessary. The browser features of an image-processing program are useful but no substitute for the power and convenience of a stand-alone browser. The plug-ins we are interested in are specialized software programs that work within a larger program.

Image-processing programs come in many flavors. Adobe Photoshop is acknowledged to be one of the premier programs for working on photos, but it isn't necessarily the best for every photographer. It has a lot of extras that are perfect if you need them and possibly a waste of time and money if you don't. Get a program that lets you do

Both Mac and Windows computers work very well for photographers. Image quality is not affected. The best bet is to pick a computer platform that your friends and colleagues use so that you have a source of support when you have problems or questions.

Apple iMac computer

ViewSonic CRT monitor

The standard CRT monitor (above) is larger and bulkier than an LCD monitor (below). Today, except for the very expensive LCD monitors, the CRT is more easily controlled for color and contrast than an LCD.

IBM LCD monitor

what you need to do and includes the features we'll be discussing throughout this chapter. Here are some of the best imaging programs for photographers:

Adobe Photoshop is a superb, full-featured program that does everything. But with all its features, it can be confusing and hard to learn. (Mac and Windows)

Adobe Photoshop Elements includes many of the key tools from Photoshop. The interface is a little more friendly and specific for photographers; more helps were built into the interface to make it easier to use. (Mac and Windows)

Jasc Paint Shop Pro is probably the fullest featured program for its price. It rivals Photoshop in the extent of controls, though the interface is geekier. What's in the interface and where it appears are totally customizable. (Windows only)

Ulead PhotoImpact includes a special Easy-Palette of very photographic effects as well as all the major controls. In addition, it has some of the best special effects and text effects available without requiring a lot of plug-ins. (Windows only)

Your computer monitor is very, very important to getting the best results from your photography. The flat-panel, LCD monitor has gotten a lot of attention lately and is very hot. It may not be the best monitor for you, though. The traditional CRT monitor, although large, is easier to adjust for color, has a better tonal range compared with the average LCD monitors, has better working angles, and is far cheaper for equivalent photographic quality. You can get a very good 21-inch CRT monitor for about $600 today and the very best in CRT monitors for not much more than $1,000. For equivalent quality and size in an LCD, you would probably have to pay $2,000 to $3,000.

Inexpensive LCD monitors do not have very good working angles (meaning color and tonality change as you move your head), and their contrasty screens don't reveal all the detail in an image. This is likely to change in the future. Get a big monitor; it's really worth it. I would recommend a 19-inch CRT or 17-inch LCD at a minimum.

A big hard drive (a minimum of 20 GB) is necessary for your images. Two hard drives offer greater protection. An optical drive is a necessity for backing up files and transferring images.

USB and FireWire ports are ways to get photos into and out of your computer. USB, either Type 1.0 or 2.0, is a necessity since so many peripherals have this type of connection. Type 2.0 is quite a bit faster. FireWire is a very high speed connection that is becoming more common, but it does you no good if none of your peripherals use it.

Card readers and scanners, covered in the last chapter, are very important parts of the system.

Printers will be covered later.

Keys to Working in the Digital Darkroom

Many photographers have tried to work with image-processing programs such as Adobe Photoshop and found the whole process difficult, intimidating, and tedious. One big reason this occurs is that much of the instruction in books and classes takes the wrong approach for photographers: It dwells on the software and not the photography.

The photo "rules." This is an important thing to remember. When the software is "in charge," the focus is not on the image; it is on learning and memorizing all the functions of the program. Many photographers have sat through classes that taught them about such things as selections and layers long before they had any idea why they might want to have such knowledge. This was simply because the

instructor thought these things were key elements of Photoshop.

As a photographer, you know your photos and what you want them to do. Sure, you might not know everything you can do with an image in the program, but that is less important than why you took the photo. Only you can know this, and your photographic intent will guide you, even through Photoshop, on a sure-and-steady, craft-driven journey that is not obsessed with technology.

Here's something else you don't always hear: You don't have to know everything about a program to use it effectively and get your money's worth from it! Remember that Ansel Adams did his superb work with only a few controls. He made his overall image lighter or darker, adjusted contrast, and then controlled small areas of exposure and contrast.

Experimenting without fear is another key idea for using the digital darkroom. Often, photographers have had to pay a price for experimenting, and many have gotten cautious and brought that caution with them into the digital darkroom. Just remember that there is little you can do to an image in the computer that can't be undone. Let yourself go, and don't be afraid to experiment.

This approach also helps you deal with any part of a program you don't know. Open up the control, start pushing the slider controls around to the extremes, and you'll promptly see what happens as the program previews the effect. Find a setting you like, and then turn the preview on and off to see what the photo looks like with and without the change. This lets you compare what you've done so that you can learn the control quickly.

The "extreme thing" technique of adjusting is

The "extreme thing" technique (opposite) for adjusting photos will quickly tell you what controls do and how much to adjust. You can't hurt the image. Small changes at first can be misleading and can fool the eye.

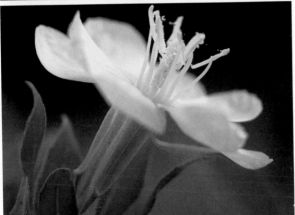

The top photo came straight from the camera. The lower image came from the digital darkroom, after some simple work—controlling overall exposure, making color adjustments, and cropping—brought out the true qualities of the scene.

simple, too. Try this: Open any photo and any adjustment tool in your program. Now quickly make extreme adjustments way beyond anything that looks good on your photo.

By using the extremes, you don't have to remember exactly which way to move a control. Just grab it and shove it in an extreme direction. Then move the controls to a good adjustment position. You will have made your adjustment faster and more accurately than if you had tried doing it in small increments.

Finally, look to the menu bar. The menus at the top of the program are organized in a logical way. Look through the menu items to get an idea of where types of controls are placed. If something sounds interesting, give it a try. There is no cost! If it doesn't work, cancel the effect or undo it and you are back to where you started.

The Digital Darkroom Process

Dealing with photos in the digital darkroom involves five fundamental steps. Of course, a lot of miscellaneous things can and will be done to a photo in the computer, but if you use this overall process as the guide for other work, you'll keep on track with your photograph:

1. Adjust overall exposure (brightness and contrast).
2. Control overall color.
3. Isolate areas of the image for local brightness and contrast management.
4. Isolate areas for local color correction.
5. Finish (sharpen and prepare for printing or other output).

This book cannot show everything possible in these areas in all the image-processing programs. So, I'll highlight key adjustments that photographers need to know that offer a great deal of possibilities for your photos. You could learn only these and gain tremendous control over your images.

Controlling Overall Exposure 1: Levels and the Histogram

The best single brightness and contrast control that every digital darkroom worker needs to know is Levels, with its associated Histogram. This control allows you to adjust the highlights, midtones, and dark shadows individually.

Unfortunately, Levels opens with a graph and scares a lot of photographers. Imbedded in that control is an excellent tool. First, you need to know a little about the histogram. It plots pixels per level of brightness, with black at the left and white at the right (the little slider triangles underneath are black and white as a reminder). Most photographs need a range of tones that begin in black and end in white to look their best.

A gap on the left side of the histogram means the photo is weak in blacks. A gap on the right

means the photo is weak in the whites. With gaps on both sides, the photo is deficient in both whites and blacks, and this usually means you were shooting in lower contrast conditions.

You must adjust the blacks and whites. Bring the black slider in from the left until it is below the beginning of the histogram slope (you can go farther to the right for blacker shadows). Pull the white slider at the right back to the left until it is just under the other end of the histogram slope. Your picture probably looks better already.

It is likely, however, to be a little dark or light. Now move the middle (gray) slider right or left until the overall photo has the correct brightness. You may want to further tweak the black and white levels for creative control.

Other controls in this window can usually be ignored with no ill effect. Eyedroppers are sometimes used to set white and black points, but they can be too heavy-handed in their effect.

Levels, with its associated histogram, lets you quickly clean up the exposure and contrast of a photo. The key to using Levels starts with the placement of the left (black) and right (white) sliders.

Peter Read Miller/Sports Illustrated

Controlling Overall Exposure 2: Curves

There are two important things you should know right away about the adjustment tool called Curves: It offers very useful controls if you spend time learning it, and many photographers will do wonderful digital darkroom work without ever learning it. The latter is a bit of heresy among Photoshop geeks, but honestly, photographers can do a tremendous amount of adjustment and control without ever using Curves.

The Curves adjustment allows you to isolate brightness and contrast control with more flexibility than Levels; however, it comes at you with a distinctly foreign interface—a diagonal line across what looks like graph paper. If you grab the line with your cursor, you can move it up (or left) and down (or right), which will make it curve and change the tones of the photo. Dark parts of the

The Curves adjustment allows you to affect different tones in an image. A flatter curve creates less contrast (left), whereas a steeper curve increases contrast (right).

photo are at the bottom of the line, light parts at the top. Moving the curve up will make the image lighter, down darker.

The maximum change is at the point where you grabbed the line, but the adjustment also occurs in a gradual manner across the whole range of the curve. This gradual change can be a very important feature, especially with photos that require much adjustment in certain tones. To isolate control to specific areas of tone, you can add (click with the mouse) anchor points to the line. Now when you move a point, the other points stay anchored. You can even add a lot of anchor points across the whole line to really limit adjustment to a small area of tonality. This can be a powerful means of adjustment. You can, for example, isolate changes to the dark part of an image.

As the curve gets steeper, contrast increases; if it gets flatter, contrast decreases. To favor the blacks, set a point low on the curve and move it gradually to the right to darken them. Then grab the line near the top and move it to the left to lighten highlights.

Controlling Color 1: Hue/Saturation

Color is such an important part of photography today. Now, it no longer has to be left to chance or to the whim of an underpaid minilab employee. You can control quite a bit of color in an image, from making adjustments to hues that don't look right to changing the color of someone's shirt. In this book we'll deal with making colors their best.

We can quickly affect the purity (hue) or vibrancy (saturation) of a color with the Hue/Saturation controls common to most image-processing programs. Often there is a lightness control as well, but this should be used sparingly. Mainly, you'll use Levels for controlling the brightness.

Usually, the first thing to check is saturation. Many digital cameras offer less color richness than the high-color films common today (this is not true across the board, because some cameras actually give very bright colors). Often, you'll want to tweak files from digital cameras to give them +10-15 points of additional saturation, and you do have to be careful here. A little extra saturation can go a long way. It's easy for new digital darkroom workers to make a big mistake: They think extra saturation looks good, so why not add a little more? They add more and more, until the photo looks odd in its color at a minimum or garish at the worst.

If your photo starts with too much color, you'll need to decrease the saturation a few points.

Hue adjustments come next. You can make an overall hue change if the photo has a color cast (only small adjustments are needed), but the main use of this control is to fix and adjust specific colors. On programs like Adobe Photoshop, you can select a color range for this adjustment window (it can also be used to affect saturation). Usually, a master color choice opens to a set of specific colors when you click on an arrow or opening button.

Select a color close to the hue you want to

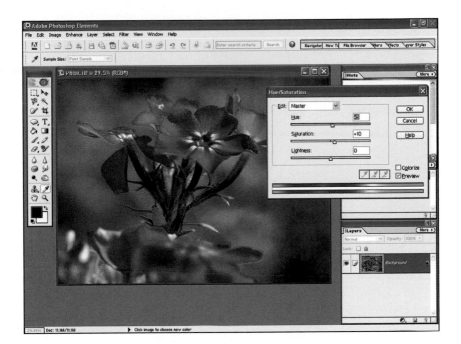

affect. Now when you change the hue or saturation sliders, the effect is restricted mainly to that color. You may also be able to click your cursor on that color in the actual photo to further refine this effect. This lets you fix things such as blue skies that have too much cyan, green leaves that are too blue, or red-orange flowers that look purple.

Many digital cameras need a boost in saturation to match what we expect to see from today's film. Hue/ Saturation can also allow the tweaking of off-color or a complete change in hue.

Controlling Color 2: Color Balance

All sorts of things can cause color casts in a photo: the wrong lighting for the film or white balance of the camera; reflected color from surrounding buildings; blue tones from the sky; fluorescent lights; light filtering through translucent objects; color shifts from a sensor or film; and so forth. Keep in mind that color casts are not all bad. We expect a color cast at sunrise or sunset. When these extra colors are distracting, you will want to remove or moderate them. In addition, you may need to add a

Scenes with several different light sources can cause problems in white balance. You can refine color with Color/Balance and Hue/Saturation controls, including adjusting specific areas of color by the use of selections.

color cast that was not originally captured by the camera (from an overly aggressive white balance function at sunset). A very intuitive control for doing this is the Color Balance adjustment feature.

This control is set up in a very straightforward manner with three sliding scales: cyan to red, green to magenta, and yellow to blue. For each scale, as you move the slider toward one side, that color will get stronger in the overall color balance of the image and the opposite color will decrease. Sometimes knowing exactly which sliders to use can be a challenge. Just try one that seems appropriate, and

make a big change to see what happens. You'll know immediately if you've picked the right one. If the change makes little difference or the photo gets worse, try another.

You'll usually find that the Color Balance control lets you favor certain tones, giving you a choice of shadow, midtone, and highlight. The ones you use depend entirely on the image and what you like.

A quick and easy way to warm up any photo is to use the midtone control of Color Balance, then add a few points of red and a few of yellow. A little added warmth can help many photos shot under a blue sky or with a flash; it also improves most pictures of people. You can increase the amount when you have low sun or sunset conditions, too.

Variations (or Color Variations) is another color tool that is actually a variant of Color Balance. Here you get the same colors as in Color Balance, but instead of sliders, you'll get little photos to click on. Each thumbnail offers a certain amount of color balance, and you click on the ones you like. You need to set the amount low or you will quickly get an unmanageable change. This tool is less precise, but it is very visual.

Isolating Changes: Selections

In addition to making overall adjustments to tones and colors in a photograph, you often have to adjust very specific parts of an image. The digital darkroom offers great features for making accurate changes to precise areas while not affecting anything else, and these include the Selection tools.

A selection is an outlined area on your photograph that allows change to occur inside of it, but not outside. It is like the boundaries on a basketball court: Any play inside the lines will help move the ball around; any play outside the lines, no matter how good it is, doesn't count.

Think of the possibilities. You can brighten a

shaded face without changing the exposure of the rest of the photo, correct an out-of-sync red rose without affecting a peach rose nearby, clean up the fluorescent light green of grandma's white hair without messing up her complexion, and so on.

There are three types of Selection tools—lasso, automated, and defined shape or marquee—and they can be used alone or in combination to deal with all sorts of selection challenges. Without a doubt, making selections is hardest when you are new to it, but gets easier with practice. Here's how to work with the three types:

Lasso tool—Many programs have three lasso tools you can use. Each tool follows your cursor as you move around an area you want to select.

The freehand lasso follows every curve your cursor makes as you create a selection. It can be hard to use as a basic selection tool because few of us, even when we practice, can follow things perfectly. It works better as a cleanup tool for fixing selections made in other ways.

For most people, the polygonal lasso is easier to use. You click your mouse once to start it, and it follows in a straight line to the next place you click. This makes straight lines really easy to do. For curves, you simply move your cursor very short distances before clicking. Finish by clicking back on the start or by double-clicking.

Automated selections—Often you must make a selection that matches a defined area, such as the sky, a person's face, or a car. In these cases, you can use automated selection tools, such as the magnetic lasso (or edge finder) and the magic wand.

The magnetic lasso finds an edge for you. You set a starting point by clicking on an edge of something

Selections let you isolate adjustments so they affect only the area within a specific section of an image—nowhere else. You can then correct and enhance with very precise control.

you wish to select. Then, as you move the cursor along the edge, the tool finds the exact edge for you and automatically snaps the growing selection line to it. It works great with strong contrasts, but it can be difficult when the contrast isn't there.

The magic wand is a great tool to use with large areas of similar tone, such as sky or a plain wall. You click once within an area, and the wand looks for all the similar tones around it to create a selection. With sky, for example, it finds the sky-like pixels. The tool's tolerance settings affect how much it grabs: If it takes too much, reduce the tolerance; if it doesn't grab enough, increase it.

Shaped selections—Sometimes you need to create a selection that is based on a specific shape, such as a circle for a wheel. Nearly all programs will allow you to create elliptical selections and rectangles. You simply move the cursor into the photo, and click and hold the mouse button as you drag the shape to the desired size.

Typically, the first selection will include something that shouldn't be in the area, or something will be omitted that should be in the area. This is very easy to correct. You remove part of a selection by holding down the Alt (Windows) or Option (Mac) key while selecting around what you don't want. You add to a selection while holding down the Shift key and selecting the new spot.

It always helps to use multiple selection tools. For example, the magnetic lasso might work well with most of a dark person standing by a light house; however, you may find it gets confused where the person's brown sweater overlaps a dark gate. You then use a polygonal lasso while holding down Alt/Option to remove the problem or the Shift key to pick up missed areas. Or you could use the free-hand lasso to put in an errant part of sky that the magic wand can't easily capture.

The last step for almost all selections is to fix the edge. Photographs rarely have edges as sharp as the

computer can create: Tones blend, sharpness fades, and so forth. To make selections isolate areas in more realistic ways, you need to blend or smooth the edge by adding a feather. Feathering an edge means telling the image-processing program to gradually change any effect at the border between the inside and outside of the selected area.

Feathering is usually part of the Selection menu. Once you finish making a selection, go to the Feather (Feathering/Blend/Smooth Edges) command. You'll get a dialogue box with a choice as to how many pixels the program should use to blend the edge (on both sides of the selection). More pixels mean more blending.

How much to blend is totally variable. It depends on the type of edge (sharp vs. gentle) and the size of the photo (big photos have more pixels, meaning more pixels will be needed for any given effect). A sharp edge—for example, in-focus, dark clothing against a light background—can probably use a small feather, maybe a couple of pixels. But if the edge needs to be soft, such as selecting a hot spot on someone's forehead, the feather will be much larger.

Although feathering can be done as the selection is made, it is best done after the selection is complete (with no feathering at first). If the first choice looks wrong, backing up and changing the feather is easier when it has no blending to start.

Tip

Selections are easier if you enlarge the selected areas and do them in sections, adding or subtracting as you go.

Cloning for Correction Problems and Creative Effects

Many folks have heard of cloning. It is sometimes treated like a party trick: "Look, we can make Uncle Bill have three eyes."

But tricks are really a minor use of cloning. In fact, cloning is an extremely important part

of the digital darkroom, allowing us to fix defects and distractions in a photo. It is an automated process that selects one part of an image and copies that selection to another spot of our choosing, usually over a problem area. We can use it to repair scratches and tears, eliminate dust, take out accidental junk that was not seen by the photographer (such as a twig in the corner of an image), remove picture debris that is not part of the photographer's intent, and so forth.

Doing cloning well takes practice, but here are some things that can help:

1. Choose a soft brush. The cloning tool is a brush tool and needs a soft edge so the cloning will blend better.

2. Choose an appropriate brush size for the problem. If the brush is a lot bigger than the defect, you will be moving more of the photo around than necessary (and this can look weird). If the brush is much smaller than the blemish, the cloning can look ragged.

3. Set your clone-from point carefully. If you start cloning and see immediately that you have a bad match, undo it and try another set point.

4. Clone in steps. Problems often occur if the cloning is just "brushed" on; you'll get more natural results if you clone in small bits.

5. Change your "clone-from" point regularly as you go. If you keep the same spot while cloning over anything bigger than a bit of dust, you may get cloning "artifacts"—unattractive, repetitive patterns that call attention to the cloning.

6. Change your brush size as you go. This helps blend the cloning.

If a stray element creeps into a photo, cloning can remove it. Set your clone-from point carefully and enlarge the area so you can see the details (this is actually a small part of a much larger image).

7. Clone back into the problem area if cloning artifacts appear. But first change both the brush size and your clone-from point.

Isolating Changes: The Power of Layers

Layers are scary for a lot of photographers just starting to work in the digital darkroom. At first they can seem like some alien computer thing and not very photographic. But don't despair. I will show you how you might see them as quite photo-graphic and well worth learning.

We'll start by using something you know: prints from your local minilab. Imagine you have taken a waterfall picture that you know will look great in the right print; you ask the lab to show you samples first—three prints that range from light to dark. Stack them in a pile, in any order, and you have just created a set of layers with different exposures. You can use your image-processing program to do the same thing electronically.

With a stack of prints, you have to remove prints from the top before you can see the ones underneath. In the digital darkroom, layers work the same way, top to bottom, and if there is some-thing solid on top, you can't see the underlying layers. To "take a print off the stack" of layers, you have to turn off a layer in the computer. You'll see the layers in a little box called the Layer Palette.

You can decide which print exposure is best by quickly shuffling your prints. In your software, you can turn layers on and off for the same effect. As you review your pictures, you might notice something particularly good in each of the expo-sures. Maybe the bright white parts of the waterfall have the best detail in the darkest print. Perhaps some interesting rocks in the shadows show up best in the lightest print. On the middle-toned image, most of the photo looks good, but the

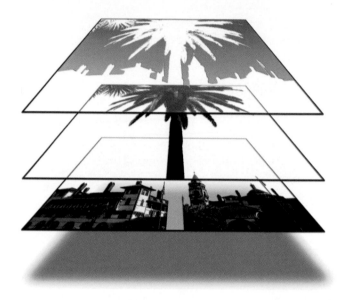

Layers are stacked images that look like one photo when viewed from the top. The Layer palette shows this stack and is always viewed from top to bottom. The photo on the right is composed of the three separate elements seen above and in the Layer palette (it is an actual photo that had these elements separated into layers).

white water is washed out and the dark rocks are hard to see.

You could literally cut up your photos and paste the good parts over the not-so-good parts: Take the white water in the dark image and paste it over the washed-out water in the middle-toned photo; then paste the interesting rocks from the light image over the too-dark rocks in the middle-toned print. The result might look a little ragged, but it would give you an image closer to what you actually saw when you took the picture.

You could do the same thing in the digital darkroom without cutting up your photos. Put the middle-toned photo on the bottom, the best white water on a layer over it, and the best rocks in another layer. Then blend the edges of each photo section (by feathering the edges after making a selection to cut them out of the original dark and light prints) so that everything looks good. You now have an image that appears to be one solid photo, when in fact it is made up of three layers that you're viewing from the top down. You can paste them together by going to the Layer menu

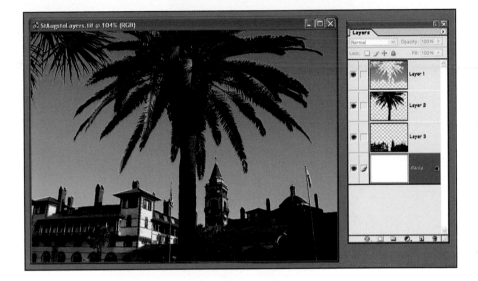

and telling the program to flatten the image.

These layers offer great controls. Suppose the direct cutouts weren't perfect: For example, the white water section had looked better, but now it is too dark. You could adjust that layer alone until it looked right. What if the rocks were too light? You could make that layer darker. And if you weren't sure how the new pieces compared with the original middle exposure, you could turn the layers on and off to see the differences.

In addition, you could move the pieces of your photo up and down in the layer stack, just as though you had a pile of photos in your hand. And if you really disliked something, you could throw a layer away and start over. Nothing would be harmed.

Where photographers typically stumble with layers is in trying to understand the technology rather than the photographic process and results. Look at layers as a way of adjusting your photos by putting pieces of your pictures in a stack, one on top of another, and then being able to change those pieces one at a time.

An underexposed or dark photo (top) can quickly be improved by using duplicate layers. Make a copy of the photo on a new layer; then go to Layer modes (the little box in the Layer palette—middle image) and change it

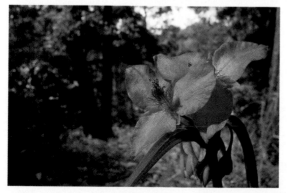

to Screen. Dark areas almost magically lighten. The same thing can be done with too bright images: Use the Multiply mode. Some photographers use this technique with adjustment layers (this is less intuitive).

Duplicate Layers

Another important technique is the use of duplicate
layers (or pieces of layers). In most programs, you
can quickly duplicate a selected layer by going to the
Layer menu or using a duplication button on the
Layer Palette. This is the same as putting two identi-
cal prints one on top of the other.

Now you can do things to one layer without any
effect on the other. This makes experimenting really
easy, since you can turn a layer on and off to compare
the effect and then trash anything you don't like.

When two layers work together, you can get
them to "talk" to each other with some very photo-
graphic results. Two great photo techniques rely on
this idea to make overexposed (too bright) images
darker and underexposed (too dark) images
brighter, both with better tones and colors than
Levels can offer.

To fix a washed-out image, duplicate the photo
so there are two identical layers. The Layer Palette
will have a mode setting (it will say Normal at first);
change it to Multiply (ignore all the other choices),
and the image will intensify as if by magic.

To fix a dark and muddy image, duplicate the
photo. Now use the Screen mode setting and the
image will suddenly reveal details you might have
thought were lost. You can use this technique with
adjustment layers, too.

You can also fix part of an image. Say your photo
has a washed-out sky, but everything else looks
okay. Select and copy the sky, then paste it onto a
new layer (many programs do this automatically
when something is pasted). Change the mode to
Multiply, and the sky gains detail (assuming some-
thing was there; this won't work with blank white
skies). Or maybe a shadow in a photo looks awfully
dark and you want to see if you can reveal detail in
it. Select and copy that area to a new layer, and use
the Screen mode to get amazing results.

Adjustment Layers

Adjustment layers are a simple form of layers with a lot of features. They are transparent layers filled with instructions that affect anything below them. Yet the underlying photos or parts of photos are not actually "changed." An adjustment layer is like a filter on a camera: The scene doesn't change, but the filter alters what we see of the scene. Because the underlying image is unchanged, you can always go back to it. Different programs offer different types of adjustment layers, but you'll usually find them with controls already discussed in this book, such as Levels and Hue/Saturation.

Adjustment layers are infinitely changeable. If you use Levels to change the light to dark tones in a photo, for example, you can open up this adjustment layer again later and change the layer's instructions to readjust the tones as much as you want without adversely affecting the image. Put multiple adjustment layers over your photo, and you can tweak and re-tweak the brightness, contrast, and color of the photo.

Still need more control? You can tone down an adjustment layer's effect by making the layer less

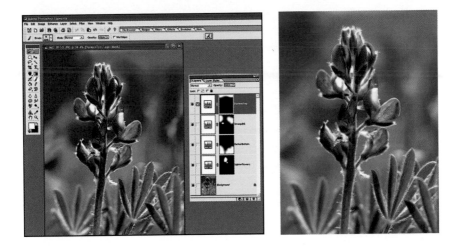

The "before" image at left shows isolated problems with exposure that are corrected in the last photo at right. Adjustment layers change the exposure; black fills the layer mask to hide the effect, and white paints it in as needed.

opaque or more transparent. If you can see through it, you reduce its consequences.

And there's even more. Adjustment layers usually have things called layer masks associated with them; these will show up as white boxes next to the adjustment control icons. A layer mask takes charge over what a layer can and can't do. If it is white, it lets the layer act normally (it "reveals" the layer). If it's black, it keeps the layer from doing anything (it hides the layer). Grays have in-between effects.

With this in mind, you can click on a layer mask to select it, and then use a paintbrush to paint the effects of the layer in or out of the photo. Black paints the effects out; white, back in.

Painting Exposure Using Levels Adjustment Layers

Adjusting exposure is an important part of the digital darkroom; however, you will often need to restrict

the brightness or darkness to certain places in a photo rather than the whole thing. Although selections work, a quick, easy, and effective way of doing this is to use Levels adjustment layers. Here are the steps:

1. Make the basic overall exposure adjustments to your image.

2. Add a Levels adjustment layer for the special areas you want to darken, and do what seems most appropriate to make those areas the right darkness (because this is an adjustment layer, you can always go back and readjust later). Ignore the fact that the whole image gets darker.

3. Fill the layer mask of this Levels adjustment layer with black (be sure you are on the layer). This will hide the effect of whatever you did to darken the image. Usually, you can easily fill this mask by going to a Fill command in the menus.

4. Without changing anything else, use a soft-edged paintbrush and a white foreground color to paint in anything you want darker (you are actually painting in the layer mask).

5. Add another Levels adjustment layer for the areas that need to be selectively lightened, and do the same thing.

6. Now you have gained very precise control over your image, which you can paint in (white) and out (black) as needed. Plus, you can always readjust the actual Levels control after you've done this painting.

Finishing: Sharpening

Scanned or digital camera images come into the digital darkroom with all the right information for maximum sharpness, but normally they are not fully sharpened. Many of the adjustments we make with the computer can affect the appearance of sharpness, so early sharpening can lead to less successful results. In addition, some controls are so highly targeted that they can potentially change details in the grain or noise in an image, making

Tip

Do not sharpen an image too soon in the digital darkroom process. Some of the adjustments can make certain image artifacts (such as grain or noise) more prominent if the photo is sharpened too quickly.

it more obvious. This is worse if the photo is sharpened too early.

Sharpening, by the way, is not used to make blurry or out-of-focus pictures sharp. That isn't possible. You'll only make sharper blurs.

There is only one tool in your image-processing program to use for sharpening: Unsharp Mask. It is highly controllable, although its name may seem weird (it refers to an old technique used by commercial printers to make photos look their sharpest). Basically, this tool looks for edges in an image and makes them stronger.

Unsharp Mask is typically found in the Filters menu. Select it and you usually get a dialogue box with three settings: Amount, Radius, and Threshold. There is a range to each; the numbers are consistent in Adobe Photoshop and Photoshop Elements, but the Amount scale can vary in other programs.

Unsharp Mask. (top) has three parameters: Amount, Radius, and Threshold. Soft focus areas were removed (above) from a sharpened layer—and not from the original image—to keep from sharpening the soft parts of the photo.

"Amount" refers to the degree of sharpening, and "Radius" describes how far the program will look around an edge to apply the sharpening. "Threshold" examines the degree of difference around edges where sharpening is affected.

If you check out books on Photoshop, you will find a whole range of sharpening formulas to use with Unsharp Mask. All of them usually work. You need to look closely at your image to be sure you do not oversharpen (see the magnified preview in the Unsharp Mask box). Oversharpening makes an image look harsh and overemphasizes lines around edges (white or black).

Here are sharpening numbers to try:

- For 3- to 4-megapixel digital cameras and small scanned photos (under 10 MB in size)—Amount 120 (or within range of 100-150), Radius 1.2 (range 1-1.5), Threshold 0 (for smaller digital cameras, reduce the Radius).

- For larger digital camera images and moderate-size scanned photos (10 to 30 MB)—Amount 150 (range 100-200), Radius 1.5 (1.2-2), Threshold 0.

- For larger scanned photos (over 30 MB)—Amount 150 (range 100-200), Radius 1.5-3, Threshold 0.

- For photos with noticeable digital grain, try setting the Threshold at 6-10 and increasing the Amount.

On some photos, you will have to avoid sharpening the whole picture. Sometimes the sky will have noticeable digital grain effects that are aggravated by sharpening. Try selecting the sky and inverting the selection so everything is selected except the sky. Then when you sharpen, everything except the sky is affected.

Or you might have a photo that uses selective focus: The subject is sharp but the background is out of focus. There is no point to "sharpening" the out-of-focus areas, because that would sharpen things like grain. Select the sharp areas so you can limit the Unsharp Mask effect to them (be sure to feather the selection).

Tip

Always feather selections (blend the edge), because the computer makes unnaturally sharp lines. You have more feathering control if you do this after making the selection with an unfeathered selection tool.

Removing Contrails

Contrails (vapor trails from jets) can be annoying bits of visual garbage that have nothing to do with what you are photographing. They are, luckily, fairly easy to remove.

Photographers typically try to remove them with cloning, but this can be difficult because of variations in sky tone. A better way involves making a selection around the contrail, feathering the selection, and moving the selection outline sideways to a bit of sky nearby (if the Selection tool is still active, you can usually do this by dragging the selection). Copy the

Contrails are an annoying bit of trash that can be removed easily, but cloning is not the best way to do it. You are better off copying a nearby section of sky, pasting it to a layer, and moving it over the offending line.

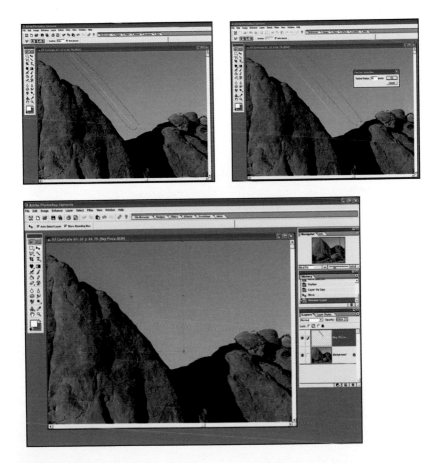

JPEG Options

Matte: None

OK

Cancel

☑ Preview

Image Options

Quality: 10 Maximum

small file large file

Format Options

◉ Baseline ("Standard")
○ Baseline Optimized
○ Progressive

Scans: 3

Size

~2099.6K / 370.95s @ 56.6Kbps

JPEG makes files smaller, but if they are made too small, problems occur. The detail on the left was saved with a high-quality setting. The right shows a high-compression, low-quality setting; the little blocks are called JPEG artifacts.

selected sky there, and paste it to a layer (using the Copy and Paste commands often does this automatically). Then use the Move tool to drag the copied piece of sky over the contrail and make it disappear.

If the match isn't perfect, move the copied sky up and down with the arrow keys (the Move tool is still selected); you can also use Levels to adjust the brightness of the piece. You may need to do a little cloning to finish the cover-up. This is a great technique to deal with almost any large problem (including scratches) in one quick move.

File Formats in the Computer

We looked at file formats in the digital camera part of the book. When you start working in an image-processing program, you may notice that you can save your images in a lot of formats. But only three are important to a photographer; the rest you can ignore. They are the same three discussed in the camera section: JPEG, TIFF, and the native format of the image-processing program.

JPEG is a very common shooting format, but it should never be used as a working format in the digital darkroom. By working format, I mean the file type you use for any photos that you are working on in the computer. JPEG is a compression file format that is used for making files smaller to conserve space or help a camera operate faster. It does this by intelligently throwing away data that can easily be filled in later, but every time a JPEG image is opened and saved, data are thrown out and rebuilt, resulting in damage to image details and tonalities.

When you have finished adjusting a photo, it can be saved as a JPEG file for a number of reasons, all related to getting a smaller file size. It is easier to send over the Internet, a lot of images can be archived in a small amount of memory, and so forth. At this point, you should reduce the file size only once and not use the file to make changes.

When viewing a scene, the eye is more discriminating than a camera. Digital darkroom techniques can help direct the viewer's eye to the key elements of an image by using traditional photojournalists' techniques.

Tonal Effects of the Black-and-White Photojournalists

One big difference between what we see and what the camera captures is emphasis. No matter what the conditions are, our brain selectively emphasizes what we are viewing and tones down the areas around it. For example, if you keep your eyes on a friend's face, you will not be able to identify small details in the surrounding area even though that area will register in your vision. The camera, on the other hand, can potentially capture all of this equally.

Traditional black-and-white photojournalists of the past knew this. They would dodge (lighten) and burn (darken) parts of photos to make sure they clearly communicated what was important in the photograph. You can do the same in the digital darkroom by toning down less important areas (darkening them) and lightening things that need more emphasis. Don't use the dodge and burn tools, however, because they tend to look too splotchy for this.

Using Layers for Fun Effects

The darkroom has long been a place for playing with photos. Photographers have enjoyed coming up with strange and wonderful colors and tones, combining details from multiple exposures for fantasy images, and even creating watercolor and other painting effects. The digital darkroom offers the same opportunities and actually allows us to be more creative in a sense, since we can experiment freely without wasting printing paper and chemicals (as in the traditional darkroom).

Layers are ideal for such experimenting and can be critical for the success of particular effects. At a minimum, layers let you keep your experiments separate and easy to compare. Keep your bottom layer unchanged and make a copy of it (or multiple copies). Apply any experiments to the copy layers. Turn the layers on and off to quickly compare different effects.

It often helps to label your layers with specific names that refer to the effects used. This will make the process easier to follow (especially if you save the file and want to examine your work later). Different programs allow you to name layers in different ways: Try double-clicking the name, right-clicking the name (Windows), Ctrl-clicking the name (Mac), or check the Help menu.

You might want to experiment with some of the effects described below.

Filters—Most image-processing programs include a ton of special digital filters that do all sorts of things, from making your image look like chrome to adding clouds. Like the mass of filters available for your camera at the local camera store, many of the digital filters look very appealing, but once you've used them once or twice, you're done. Luckily, they don't cost you anything (unlike the filters from the camera store), and some will actually become important parts of your toolbox.

Tip

Use layers to combine different exposures of the same scene. A simple way to do this is to put the best photo on top, the other exposures below. With a soft brush, erase the poorly exposed sections of the top photo to reveal the good exposures below. A more advanced technique is to use layer masks.

With layers, you can try out filters easily. Add duplicate layers, as needed, for as many filters as you might like to try. Apply one filter per layer, and then turn layers on and off to compare. Here is a very good place to label your layers by the filter name and take some notes, since the filters can be applied with different controls.

Painting Effects—Some photographers like to give images a painterly effect, and many digital filters may seem perfect for this because they usually include such things as watercolor, paint daubs, dry brush, and so forth. You can start by trying these on separate layers, but you may discover, like many photographers, that the effects don't give you exactly what you expected.

There are solutions for this. Try some of the excellent plug-in programs designed specifically to work with your image-processing program to make "artistic" or "painting" effects with a great degree of control. Also consider using multiple filters with layers. Begin by duplicating your photo onto a new layer and applying a filter, such as the watercolor filter. Then duplicate the altered layer onto another new layer, and try another filter, such as paint daubs. This can lead to very interesting results, and because you are working on layers, you can adjust how much of each layer shows through (even experimenting with showing some of the original, bottom layer) by adjusting the opacity/transparency of each.

Another great technique is to have both the painting and the original photo as parts of the final image. To do this, apply a painting effect to a copy layer of the overall image, and then remove that effect over your subject (by erasing or using a layer mask). This allows the bottom, original photo to show through, so you get the effect of a sharp, photo-quality subject surrounded by a painterly environment.

Soft Focus Effect—With certain subjects, such

Using layers together (opposite) offers great possibilities, such as this easy soft-focus effect. Copy your finished photo to a new layer and blur it heavily with Gaussian blur. Next, change the opacity of the layer until the sharpness of the original image starts to show through (56-60 percent often looks good, but the effect is very subjective).

as portraits and flowers, a photo can look too sharp. Blurring doesn't help. You want something that looks soft and sharp at the same time—like the old-fashioned portrait lenses produced.

Combining Completely Different Photos—For special effects, layers become a necessity. You can easily make collages of multiple photos, for example. This can be a neat way of creating one "photo" that shows off a number of images for creative or story telling effect. Open up the series of images you want to combine. Choose your background photo, or create a new, blank image with a plain background. Next, reduce the size of the other images so they will fit comfortably on the first (use the Resize command; see the later section on resolution for more information).

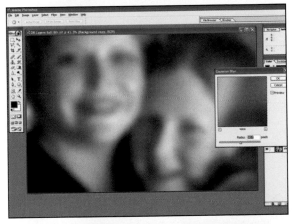

On most programs, you can select the Move tool from the toolbar, move your cursor to the first photo, click and drag the image all the way to the background photo (you must move your cursor all the way into that photo), and release the mouse button. Now bring in the other photos; in most programs they come in as separate layers. Move them around to a nice design, change the sizes, rotate them, add borders, and even add text if you wish.

The top left photo is actually a miniature set about one foot tall. To make a composited illustration work, all photo elements must be photographed in similar light, from the same angle and focal length.

Of course, you can use the same basic technique to create unusual photos that combine parts of various images into something totally new. In this case, open up the photos as before and select around a specific element of one photo that you want to add to the larger image (for example, a person that needs to be in the background photo; use any selection tool that works). After copying the selected area, go to the larger photo and paste it in (check the Edit menu). Now move the pasted piece to the correct position (using the Move tool again). If it is too small or too big, you will have to resize this picture element. Look for a Transform part of your menus and then the Scale command. Transform/Scale lets you change the size of a layer element without affecting anything else.

Tip

Compositing for illustrations can be made more effective by adding a slight bit of noise (from Filter menu) to help match the grain in different picture elements.

The key to making a photo-illustration work is to have images that go together well from the start. No matter what tricks of blending you try, these photos never look right if the final result just looks like random shots pasted together. Photographers who specialize in this type of fantasy imagery will typically try to match the direction, color, and contrast of the light in each photo element. In addition, they will strive to match the focal length of the lens, the angles to the subjects, the depth of field, and more, all to make the final composite image look good.

Blending is accomplished by feathering edges once selections are made; using things such as defringing commands; employing layer masks; and basically doing a lot of work. If an edge is really a problem, you can select the picture element on its layer, add a small feather to the selection, invert the selection so it only includes the feather and not the object, and hit Delete to remove the offending item (you may have to try different feathering amounts to get this right, or use the eraser tool to remove a problem spot).

BRUCE DALE
Photojournalist and Illustrator

Courtesy Bruce Dale

BRUCE DALE began shooting for NATIONAL GEOGRAPHIC magazine more than 30 years ago. For him, technology has often been a way to get a better photograph. He was the first photographer to mount a camera on the tail of a commercial jet for a very distinctive perspective on landing; he worked with holographic images when that technology was still very new; and he collaborated with his son, Greg, to develop a device that allows the precise triggering of a camera by sound waves or a subject crossing a light beam.

Today Dale photographs almost exclusively with digital cameras and uses film only when a client asks for it. He has a busy shooting schedule for a number of publications and clients, including Panasonic and Shell Oil.

Working this way—taking pictures in an objective, photojournalistic manner for publications while providing photo-illustrations for clients—is still somewhat unusual for photographers. Writers for news magazines and television news programs have easily combined the reporting of facts with the writing of novels, and now photographers are beginning to enjoy another creative outlet as well.

Layering multiple images together (as seen on the following pages), Bruce Dale produced this photo-illustration for Shell Oil. His technique created the appearance of a very unsafe situation without requiring

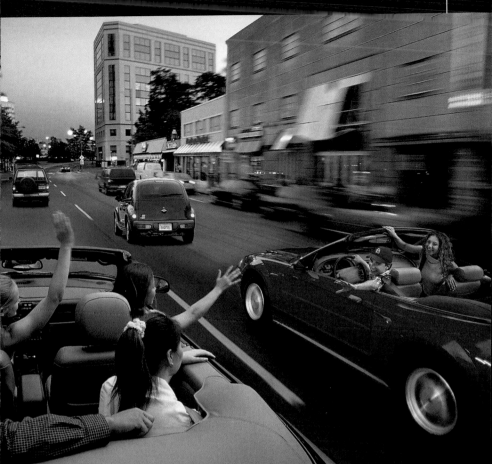

participants in the photo shoot to actually face danger. All of the elements had to be photographed very carefully so that they matched and looked as if they had been in the same photo from the start.

Bruce Dale's photo-illustrations for Shell are quite remarkable in their complexity, often illustrating safety tips by showing how not to drive. Photographing bad driving habits directly could endanger both the photographer and the subject, yet a direct approach is exactly what his clients initially thought Dale would take.

"They really weren't expecting me to do a high-tech job for them," he explains. "They figured I'd just shoot a set with stunt drivers. But I showed them how we could do this safer, cheaper, and better in digital."

Dale very carefully builds his pictures from multiple photographs taken specifically for the

The complexity of the image on the previous pages is revealed in this exploded view. Every part is critical to making the photo-illustration work, from the blur on the side of the car to the sizes of the cars in the distance.

project (all of his first work was shot on film and scanned). This way he can match the images exactly and put them together realistically. "This is very important," he says. "I am careful to use the same light, lens focal length, and even the inclination or angle to the subjects used in the photo. This is the only way to make all the pieces work together."

He has put as many as 20 separate elements together in a single photo-illustration in this series. Some photographers take shots of individual pieces and turn them over to someone

else to complete the assembly. But Dale doesn't like that idea: "I really hate to do all the photography and give it to someone else. There are just so many variables that need to be controlled for the final photo to look right. I want it all to match, and I know the pieces and what I was after when I shot them better than anyone else can."

The process often takes a lot of time to complete, notes Dale, and the same might be said about the rest of his digital work. "It is darkroom work," he explains. "You have the opportunity to lighten, darken, and make other adjustments to the photo. You get the chance to make every photo look the way it's supposed to instead of a limited image based on the arbitrary way the camera records the scene. That plus organizing and managing the photos on the computer can take time."

This time investment is not for everyone, he acknowledges. "If you are happy with film, you may want to stay with it. Digital can especially absorb a lot of your time when you are making prints. But you can also take digital files to a lab. I've seen some amazing things coming from labs, including those kiosks that let you make prints on the spot."

Obviously, though, Dale finds the time and effort to be worthwhile. He especially likes the immediacy of the process. He can shoot and see what a photo looks like almost instantly, not hours or weeks later. "You know you have the picture right then, whether that is a straightforward magazine photo or pieces of a photo-illustration to be composited later," he says. And that helps give him an edge in two worlds: photojournalism and photo-illustration.

For his work in photojournalism, Bruce Dale draws a hard line: absolutely no modifications to a photo—no light poles removed—nothing. Many photographers, he predicts, will find this approach to be an ethical challenge.

Ethics and the Digital Darkroom

WITH THE ADVENT OF PHOTOSHOP and its amazing power over an image, there has been a lot of new discussion about truth in photography. Some people have gone so far as to say you "cannot trust a photo today." In some ways, that may actually be a good thing, because, believe it or not, it probably has never been wise to trust all photos.

Nearly 60 years ago the photojournalist, W. Eugene Smith, said this: "There must be a realization that photography is the best liar among us, abetted by the belief that photography shows it as it is." He made this comment long before anyone even considered computers for imaging, and what he meant was that a photo looks so real, a viewer automatically thinks it is.

What's Real?

W. Eugene Smith's statement is still true. Yet photographers don't usually run into ethical trouble because of big lies. They get into trouble because of how they shoot and how their images are handled afterward. Often, the demands of professional work, especially in the news media, require photographers to look for drama over content. Such pressures can be so strong that lapses in judgment can occur and lead to questionable ways of working with photos.

Unfortunately, some photographers push the ethical limits of their work with digital technology. During the second war with Iraq, a photographer

from a major daily paper took a series of photographs showing a soldier with civilians. A couple of images were quite dramatic, but they were evidently not dramatic enough for the photographer. Using digital technology, he put the view of the soldier with the strongest gesture into a different photo showing a more active father and child.

Although the content of both images was quite similar, the difference in emotional effect was quite dramatic. The new photo was more intense, but it depicted something that never happened. The photographer was fired from the paper.

An obvious fantasy like this darkroom-created image will not fool anyone today, but in the early 1900s fairy cutouts were added to regular photos—lies without the computer— and fooled some people in England.

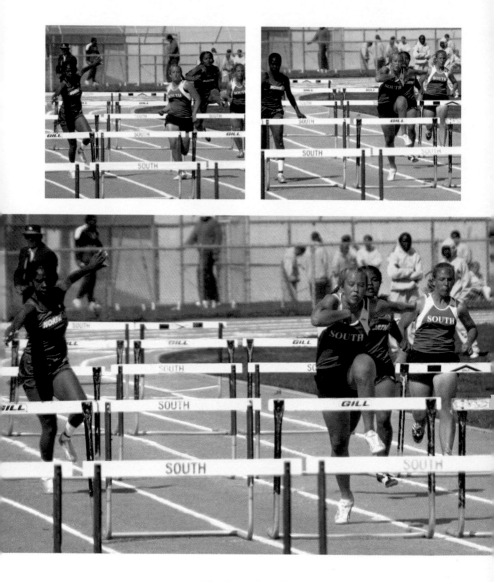

The lapse in judgment was certainly not caused by the computer. The photographer had to make a decision to change the images in ways that would alter the emotional content of the original scene. Such a decision can just as easily be made when taking the photo. A recent controversy started with what seemed to be a simple, yet powerful, news

The top two photos (opposite) are real, but by combining the more dramatic parts of each, a far more impressive image appears. The new photo is a lie because it creates an emotional content that never existed.

photograph in a major newspaper. The photograph, published during a time of strained Arab-U.S. relations, showed a young boy standing in front of a sign for a Middle Eastern grocery store and pointing a gun as if he were shooting at something. It seemed to make a strong statement about the times.

In the end, the photo was not what it appeared to be. Witnesses had seen the photographer talk to the boy, who had been playing in the neighborhood, and then lead him to the sign and direct his actions with the gun. As an illustration, this might have been OK, but news it was not. And the computer played no part in the controversy.

Defining Truth

For a while, when the whole digital thing was very new, photographers who had not used the technology were afraid of it and started to make rules about images that were based on the limitations of traditional photography and not necessarily about reality. They retreated into what, for them, was safe and known: film photography.

Among the biggest concerns were composites (more than one image used to create a photo). People thought photographers would no longer have to trek to Africa, for example, to get great photos of lions on the veld. They'd just buy a stock photo of the veld, take a picture of a lion in a zoo, and combine the images in Photoshop. These people had never actually worked in Photoshop, or they would quickly have understood how difficult it would be to make the results believable.

Sometimes, a composite is exactly the tool that's needed. If a photographer took two photos of a scene—one favoring the dark areas, one favoring the light—and put them together in one image that expanded both images' tonal ranges (described earlier), the result would be much closer to reality than a single exposure.

Of course, composites have the potential for lying, just as any photograph does. You could put two people together who had never met, for example, or change the décor of a room so it matched a preconceived idea of what a scene should look like, and so forth.

Machine vs. Man

Another issue arose over how much one could clean up a photo and still have it be true. This is definitely tricky. You could remove details of a photo that weren't significant parts of a composition, but would the loss of those details influence the viewer's impression of the image and ultimately the truth of the photo?

Photographers and photo retouchers have been changing things in photography since it began, long before any computers were involved. Distracting lines were painted out, wrinkles removed from portraits, logos were corrected on buildings, and in an extreme example of using retouching for deliberate lies, government officials were routinely removed in official Soviet photos since Stalin.

Whom Do You Trust?

Photographers can go too far on occasion; even if they are not trying to lie, they can create photographs that are certainly misleading. We should not forget, though, that this has always been true of any form of communication, from words to images. A reporter can lie with seemingly true words or by only reporting superficial truths,

whereas a photographer can do the same by determining how and when he photographs (having nothing to do with the computer).

Ultimately, truth in a photograph, just as in news reports, comes down to the credibility of the photographer and the source. Knowing that the policy of a publication is to never alter photographs under any circumstances gives us faith that images in the publication will be true. On the other hand, people find it difficult to trust a photograph in a sensationalist tabloid, even when it does show the truth.

If people want to fool others with photographs, they can do it whether Photoshop is available or not. What's true and false in a photo is highly dependent on the objective of the picture and what it is really about. Photography, like writing, is used for journalistic truth, dramatic illustration, and pure fiction. The objective of each is different, and "truth" for a fictional piece is quite changed compared with journalism.

We must continue to separate truth from technique. Just because someone can use a word processor to change text is no reason to believe the text has been changed to alter its relationship to reality. The same is true of the digital darkroom.

There is a place for strongly controlling images to ensure that they communicate carefully and incorporate only truthful enhancements. There is also a place for creating fantastic images that start in reality and end up in a place of imagination and creativity. However, each undertaking needs to be clearly identified, just as written works are clearly labeled as fiction or nonfiction, so that truth will continue to be part of photography. And we need to reject all photographs designed to deceive us, understanding that this can happen whether a picture comes straight from a camera or from a digital darkroom.

GEORGE LEPP
All About Control

Tim Grey

GEORGE LEPP is known for the range of his nature images: He does everything from landscapes to wildlife to highly magnified close-ups for publications around the world. He is also the "Tech Tips" columnist for *Outdoor Photographer* magazine. What ties all of his work together is control. Lepp has always worked with whatever photographic tools he needed to control his variables, to "optimize the possibilities", as he describes it. And his transition to digital has given him the greatest control yet.

"Photography is all about making tools do what we want," he says. "With digital photography, we have the total package of tools to give us everything we need from the shot to the print. For so many years, we were stuck in the capture mode. We could take the picture, but we had little control over the final output, whether prints or published in a magazine."

On the surface, that control might seem like a restrictive, less creative way of getting a photograph, but Lepp says the opposite is true. "Digital photography has made us far more creative as photographers. In the past, we'd try an experiment, then have to wait days or even weeks for

George Lepp has long been a control junkie. He loves to get the most out of his images and will use whatever equipment it takes, from a wide-angle tilt-shift lens for close-ups to a super telephoto for

landscapes. Digital photography, for him, extends those possibilities. For this shot, the digital darkroom allowed Lepp to bring out the rich color of the Kukenhoff Gardens in the Netherlands.

the results if we were in the field. Now you take a photo, check it, and try something new while you're still there, right with the subject. That lets you learn immediately what your tools are doing and how to better control and use them for creative and expressive effect."

George Lepp first got interested in the control offered by the digital medium when he saw what was being done with high-end equipment about 20 years ago. "I saw some early image processing done by very expensive equipment like that from SciTech. This was gear that could easily cost $500,000, so this was not something everyone

Lepp shoots 100 percent digital today. He finds it a great advantage in photographing everything from flowers to shorebirds, because Photoshop lets him get the most from the tones and colors in his photos.

was going to use. You had to hire someone else to do the work—if you could do it at all."

As soon as prices for computers and memory dropped in the mid-1990s and Photoshop became available for Windows, Lepp quickly started experimenting with the technology. His work has evolved so that today he shoots 100 percent digital and spends a lot of time bringing the most out of his photos in Photoshop. "If you asked me ten years ago if it would be possible to do all this, everything that you could do in a

color darkroom, but with no toxic chemicals, totally dry and in the light, I would have told you, 'no way!'"

Lepp admits that getting to his level of control does have its challenges, including the learning curve. "There are so many things to learn if you want to keep up with all the technology," he explains. "There is really a lot on the table, and it is all pretty good."

But you don't have to learn it all to make good use of the technology. "Keep it simple," he advises. "Start with just the things you need to make your photos better. Don't be intimidated into feeling you have to know everything about Photoshop, for example. You don't. You can have a lot of fun, learn much, and get some great photos if you just focus on the basic concepts of photography you already know and look for the ways that work for you that use these concepts."

In Lepp's view, digital photography is definitely a craft that can be used by everyone, including people who just want a fun thing to do and serious photographers who want to do things in a whole new way. "There are levels ranging from the very inexpensive to the unbelievable pro level," he says. "You can learn a lot from the advanced compact cameras and eventually move to interchangeable-lens SLRs. But one thing I feel you really need is a good computer. If your computer frustrates you, you won't like the process."

George Lepp is having more fun than ever with all levels of his photography, from highly technical pro work to making e-mail postcards to send back home from his trips. "Despite all the control possible, digital for most photographers was a compromise just a short time ago," he says. "Not any longer. Now the quality of digital photography matches or surpasses film."

The Print

THE MODERN ERA OF DIGITAL PHOTOGRAPHY really got going when high-quality color ink-jet printers were introduced. Before then, if you were considering using a computer to work with photos, you faced a big limitation: What could you do with the images?

Almost all modern ink-jet printers are capable of high-quality photographic printing. The so-called photo printers offer advantages, but even inexpensive printers do wonderful work with photos, given the right attention to the printing process.

An ink-jet printer lays down a very fine pattern of ink as a printer head moves back and forth across an emerging print. This pattern is strongly affected by the size of the ink drops, the available printing colors, and the software algorithms controlling the mix of colors.

The Keys to Printing Success

Printing is a fairly simple process. These are the key things to keep in mind:

Paper—Without the right paper, you can never get true photo quality.

Image resolution—The wrong image resolution is a frequent big mistake; it is often confused with printer resolution.

Printer resolution—If you remember nothing else about printing, know this: Printer resolution is totally different from image resolution.

Printer driver—For photo-quality results, the

Courtesy Canon USA, Inc.

special software that controls the printer must be set and not just used in its default settings.

Before moving on, ask yourself a very important question: What is a good print? Then think about the answer: a print that meets your needs. A good print will vary from photographer to photographer. Even the same photographer may have different "good" prints from one year to another.

Ink-jet printers today give photographers the ability to make superb photographic prints in their own homes or offices.

Paper

With the right paper, you can create wonderful photographic images. With the wrong paper, no amount of work will give you quality prints.

When choosing paper, you have several things to consider, all of which are a bit subjective. You are always safe with paper from a printer manufacturer, because a printer company will provide paper that makes its printers look good.

The surface of the paper is a personal, yet critical choice. Paper surfaces vary from glossy to matte, with choices like luster somewhere in between. Glossy gives the most brilliant images, with the crispest tones and brightest colors. It will also bring out the maximum sharpness of images. Matte, on the other hand, offers tones and colors with more subtlety and less harshness. Photographers will offer very strong opinions on which is best, yet both are "best" and "worst" depending on what you like.

Digital camera photos *(opposite)* frequently need to be resized to a printing resolution. Do this first by changing resolution without any other file parameters (here, by keeping "Resample" unchecked).

There are also a lot of photo-quality, specialty surfaces available from a variety of sources. These include canvas, silk, Mylar, and a whole range of watercolor papers. Many photographers discovered that watercolor papers give quite attractive, matte-surface results for photos. Watercolor papers vary in their surface qualities, in their texture, and in their warmth or whiteness.

The thickness and weight of a paper strongly influence whether we relate to a print as a "real" photograph when it is held. We expect a photographic print to have a certain heft and feel to it. Lightweight plastic polymers are used for very high-quality glossy prints, but you may be disappointed holding them, because they are floppy.

The brightness of paper affects the brilliance of color and the "snap" of an image. Generally, a whiter, brighter paper will provide the best prints if you want maximum color and tonality; however, some watercolor papers will be warm in tone and not necessarily pure white or even that bright. These can give images an aged, almost painterly quality that can be very attractive, but the look is not for everyone.

Image Resolution

Image resolution is not the same as printer resolution. All ink-jet printers are designed to handle a certain amount of image resolution, and although it might seem logical that more would be better, in this case more is usually worse. Think of filling a coffee cup. Just the right amount of coffee makes the cup perfectly filled, but too much coffee makes a mess. Instead of a mess, more resolution usually results in lower image quality.

How much is enough? It used to be that 300 dpi (or ppi, if you are a purist) was the standard (to repeat, this is image resolution). This worked because all ink-jet printers could make quality prints at that resolution (they still can, which means it is a safe number).

The algorithms, or computer programming, of modern printer software are extremely good. They

FOLLOWING PAGES: A fine print for the wall has always been a photographer's goal, but getting a great print from a lab has often been hard. Today, many digital options offer superb print quality, including from your home printer.

Jim Brandenburg

can handle much lower image resolutions and still maintain equal photographic quality. On many printers, you can drop the image resolution to 180 dpi without any noticeable effect, and on some papers (especially watercolor paper) you may even be able to go lower. The only way to know what works for you and your setup is to experiment.

The advantage of lower image resolution is that you can make a print larger with the same amount of image data. You don't have to interpolate (increase a file size through software). All you're doing is affecting a file's instructions to a computer as to what dpi/ppi to use for an image. The same 5-megapixel file size will print about a 7x9-inch photo at 300 dpi, but a 10x14 at 200.

Printer Resolution

This fact is so important that I have to repeat it: Printer resolution is different from image resolution, and very high printer resolutions (2,400 dpi or more) have little to do with real photo-quality printing. Generally, you can allow a printer to set its own optimum resolution for a given paper type. You can also test different papers. You may discover, for example, that a resolution of 720 dpi works fine on most papers, but higher resolutions such as 1,440 dpi are needed for glossy.

Resolution of the printer is important, but the very high resolutions now hyped by manufacturers are usually not at the true photo-quality settings. These resolutions are so high that the printer can't put down the optimum photo-quality pattern of ink droplets that it is capable of. Some research indicates that the eye is incapable of discerning resolutions higher than 1,500 dpi. The higher resolutions do affect printing, though. They make it much slower and use up more ink, but the photos don't look any better (and sometimes they look worse).

Printer Driver

Though often overlooked, the printer driver and its settings are important parts of the printing process. The driver is the software that actually controls a printer, and many photographers who are struggling to make good prints often don't realize that a driver needs to be set.

You have to choose a paper type for the printer to do its job. On some printers, you just do that and the rest is done automatically. On others, you need to choose things like mode, which will include Automatic, Photo Enhance, and Custom. These settings use special algorithms written by the printer engineers to optimize prints. Automatic does it all for you as long as you choose the correct paper. PhotoEnhance will usually give you some choices, such as portraits or nature, to enhance the colors in those types of images. Custom allows you to tweak and save specific settings (such as printer resolution or color adjustments) to adjust your printing. The only way to know if these settings will work for you is to try them. You may find the Automatic mode is just fine for a certain paper, but you need to go to PhotoEnhance for another.

The printer driver must be set properly to get a good print. Here are examples of parts of printer drivers for Windows and Mac. One key setting is paper choice.

Can You Match the Monitor?

This is a tough one. A monitor image truly is different from a print, and spending a lot of time trying to get an exact match can distract you from what is really important—a print you can be proud of. Consider these facts:

A monitor's colors are made up of glowing or

lighted pixels based on the RGB (red, green, blue) color space of computers, whereas a print's colors are created by light that must reflect through dyes or from pigments and white paper, all based on a different color space (CMYK or cyan, magenta, yellow, and black).

Colors on a monitor will often show slightly varied emphasis compared with prints because of the dissimilar ways they deal with color.

No one ever puts a monitor on the wall; a very important thing for a print is not how well it matches a monitor but what it looks like.

The key to successful printing should be a good print, not a print that arbitrarily matches a monitor. Still, it is important to have an accurate monitor that responds in a consistent way, so changes you make on the screen are reflected properly in a print. This is a starting point for color management. With this in mind, there are a number of things you can do to improve your percentage of good prints:

Calibrate. For your monitor to be consistent, you should calibrate regularly. Programs like Adobe Photoshop and Photoshop Elements come with calibration wizards.

For more control, there are programs with sensors you attach to your monitor, such as Monaco EZcolor and Color Vision Spyder.

Improve your workspace and be sure it is surrounded by neutral colors. Our eyes compensate for the surroundings. If you have a monitor on a red desk, for example, there is a good chance that images on the screen will be "colored" by your eyes' compensation for the red.

In addition, be mindful of the light in your room. If it is constantly changing, from sunlight to skylight to incandescent, you may find your prints look different when printed at various times of the day. Your best bet is to keep the room somewhat dim, with light changes kept to a minimum.

React to the print. I think this is one of the most

> **Tip**
>
> Testing was an important part of the traditional darkroom, and it can make a significant improvement in digital prints, too. Testing can mean the difference between adequate and stunning prints.

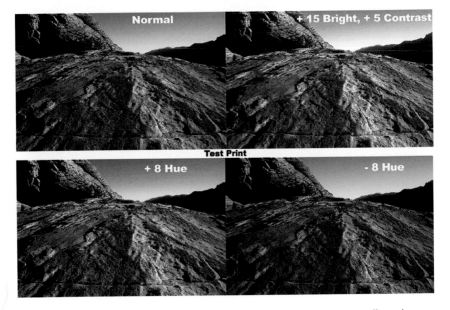

To make test prints more efficient, put multiple images on a page, adjust them differently, then print the page (top). VividDetails Test Strip (below) can adjust color and make automated test prints.

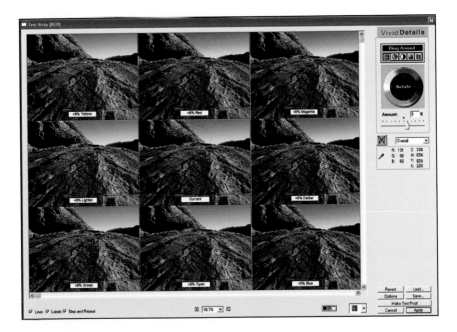

important parts of the printing process, yet so many photographers feel that they must do everything the "right" way (based on the advice of digital gurus) or an image won't be good. This simply isn't true. Look at a print when it comes out of the printer. Really look at it, without comparing it with the monitor, and decide whether you like it or not. If you don't like the print, or it isn't quite right, then look at the monitor to see where it differs in terms of color, tonality, etc.

Do a final examination of the print after it has "dried" for a while. A little known-fact about printing is that certain tones, especially blacks from some printers, aren't fully "developed" for anywhere from minutes to hours. In addition, check your print in the light that it will most likely be displayed under.

Test. Test, test, and test again. This is a craft. The more you print, the better you will get. Traditional darkroom photographers constantly did tests to get the best prints, and you will need to do the same.

Traditional darkroom workers sped up the testing process by using a test strip. You can do something similar by first creating a page that includes many small versions of your photo. Then select and adjust each image differently (recording your adjustments so you know which work best).

For example, you could arrange four 3x5-inch images to print on one sheet of paper (some programs offer automated printing functions to do this). Then adjust the separate images in different ways, keeping the top left unchanged, and print to see the effect (e.g., lighter trials or varied color tests). You can also use a program called TestStrip (*www.vividdetails.com*) to do this.

Color Space

Color management is a way of getting all parts of the digital workflow, from image capture to printing, to communicate in such a way that colors are

more consistent. It is not a perfect science as some would have you believe, and can be as much an art as technology.

It is worth knowing some of the basics, however.

Color space is a key concept that refers to the range of colors a system can handle. The computer by default works with the RGB (red, green, blue) color space, but this is actually broken into variants of the space for photography. CMYK, another color space used in the publishing industry, is far more limited than RGB. Photographers should not use it for working with images.

Digital cameras typically deal with a somewhat limited, though supposedly more colorful, color space called sRGB. Pros like to work with a broader range space such as Adobe RGB (1998). Some digital SLRs include this as an option, which can mean more color range is captured.

The capture color space (color space used by a digital camera or scanner) can be changed once the image file is in the computer (many photographers change the sRGB to Adobe RGB), but this is not possible with all software. That may or may not be important to your work. The color space tells the computer how the colors are supposed to look and what range of adjustment is possible.

Tip

Color management helps keep color consistent through a chain of digital gear. Each piece is "profiled" as to its reactions to color. A "closed system" works best because you can control every part of it.

Edge Burning—The Complete Print

For traditional darkroom workers, edge burning was more than a technique. It was a key finishing step for a print. This process involved the slight darkening (burning) of the outside edges of a photo. Ansel Adams considered it a necessity for many images, believing that the eye had a tendency to wander off the edge of a photo that hadn't been subjected to it. The darker edge kept the viewer concentrated on the subject and composition.

This step is very easy for the digital darkroom. An easy way to do it is to select the outside of an

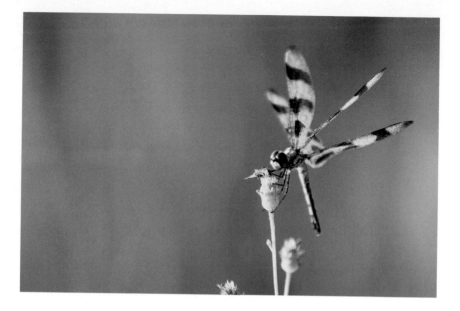

image and use the Brightness/Contrast control to darken it.

After the selection is made, go to the Selection menu and invert the selection. Next you need to create a large blend around the selection edge, by using a feather of at least 70 to 80 pixels.

The edges can now be darkened with the Brightness/Contrast control. If you turn the preview on and off, you will be amazed at the depth that edge burning adds to an image. You can isolate the effect by working with Brightness/Contrast on an adjustment layer.

Archival Quality

Making a print that will last is a worthy objective. It is most annoying to put a photo on the wall and six months later find it terribly faded. That was exactly what happened with the first ink-jet prints.

Longevity has increased dramatically since then, and now many printers can create photos that will last at least as long as a set of drugstore

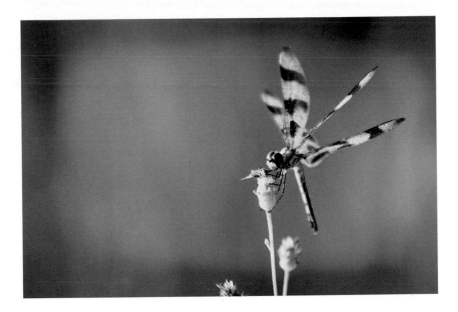

At first, these two photos may appear identical. But look closer and the right one seems to have more depth: It keeps the eye focused on the dragonfly. The edges have been darkened based on the edge-burning ideas of Ansel Adams.

prints (8 to 14 years). With the right papers and inks, and the proper storage, an image can survive more than a hundred years.

Paper is a critical element in this process. Matte papers typically have the longest life since they absorb and somewhat protect the ink. The shortest lived tend to be the glossy papers.

Ink is the other key ingredient. For a long time, ink-jet inks were not very lightfast and could fade within months. Most inks are actually dyes, which have the shortest life expectancy of ink-jet inks; however, the latest printers offer a life of 20 years or more with these inks using matte papers.

Pigmented ink is relatively new for ink-jet printers. Not all manufacturers offer it because it can be tricky to handle, but it lasts a long time, typically 60 to 100 years, or more.

Traveling With a Digital Camera

RECENT YEARS HAVE SEEN an increase in security measures for travelers. Traveling with gear can be a challenge because of restrictions about carry-on baggage, and film is threatened by the big scanners that analyze checked bags. What can you do?

One idea is to start shooting all digital. For the travel photographer, a digital camera offers several very distinct advantages over film:

1. You can carry a lot of exposures in very small memory cards in a bag with the camera(s). You don't need space for multiple rolls of film.

2. There is no risk of fogged film from luggage scanning since you have no film.

3. You can be sure of your photography. Since you can check the shot with the LCD, you can be certain you have what you want while you are still at your travel location.

4. You can send digital postcards back home during your trip.

One thing that can be an issue when traveling with digital gear is figuring out what to do with the photos. You could just take big memory cards and keep images on them until you get home. Today, memory cards are available in gigabytes, so this is a possibility.

If you travel with a laptop, you can easily download your images to its hard drive. If your laptop has a CD-burner, burn CDs of your images as you travel. A lot of pros do this because of the protection it offers.

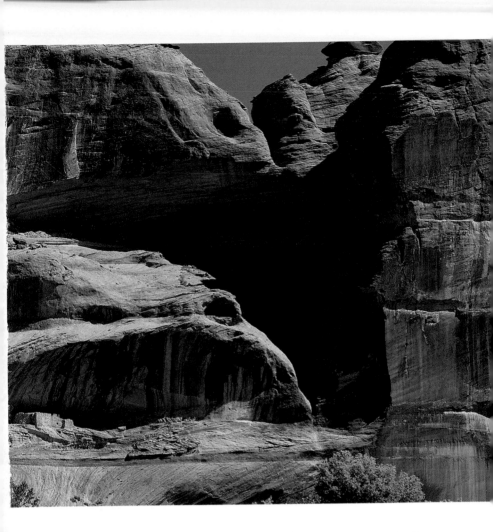

Now on the market are portable CD drives that allow you to download images directly from a memory card to a CD. They are smaller than typical laptops, yet offer great piece of mind. You can also download images from memory cards to portable storage devices that are only a fraction of a laptop's size. This can make travel very pleasant.

One thing you want to be sure of when traveling is power for your digital camera. Be certain you have the right adapters for your battery charger and have at least three sets of batteries.

Places like the bottom of Canyon de Chelly are not easily visited. A digital camera can ensure you get the shots you want while you are still there.

Resolution Math

Resolution—the dreaded "R" word. Let's see if we can make some sense of it. As we've discussed earlier, resolution mainly affects the size of the image used, and it refers to two rather different parts of the digital process: the image (scanning, digital cameras, and in the computer) and the printer (how ink is put on the paper). The most confusing part is image resolution.

Image resolution in computer terms comes in two flavors: linear and area. Linear resolution is expressed in how many dots, or pixels, fit per specific distance along a linear line (for example, 72 dots per inch or 72 dpi). Area resolution is the total number of pixels in an image, usually expressed in the vertical and horizontal dimensions. A scanner starts with linear resolution. Once scanned, an image will have a fixed amount of pixels along each edge, giving it an area resolution. A digital camera starts with area resolution.

Once the image is in the computer, the linear resolution is easily changed with no effect on the photo (for example, 300 dpi to 200 dpi, or ppi). All this does is tell the computer to look at the photo differently—to spread the pixels out so that only 200 are assigned to each inch, not the 300 as before. There is no change to the actual pixels.

This gets confusing because an image always has both linear and area resolution. Linear resolution is meaningless without dimensions, which means it is directly related to area resolution. Your image-processing program will usually help you out. Somewhere in the program is a place to change resolution, and there you will see dimensions as well as area and linear resolution. The important thing to remember is that linear resolution (dpi/ppi) determines the output size of the image based on the amount of pixels available.

Say, for example, you scan a 4x6-inch photo at

Tip

Most digital camera images must be adjusted so their resolutions will be appropriate for their purposes, from print to e-mail, printed page to the Internet.

Resolution Reference Charts

Input Resolution

Scanning decisions have to be made based on the relationship of resolution and original size.

Different scan resolution, different original size, same size files

Original (inches)	Scan Resolution	File Size
8x12	300 dpi	24.7 MB
4x6	600 dpi	24.7 MB
1x1.5 (35mm)	2,400 dpi	24.7 MB

Same scan resolution, different file and image size

Original (inches)	Scan Resolution	File Size
8x12	300 dpi	24.7 MB
4x6	300 dpi	6.2 MB
1x1.5 (35mm)	300 dpi	.04 MB (400KB)

Image Resolution

Output decisions have to be made based on the image size and the needed resolution of the intended use (printer, web, etc.)

Different dpi and image size, same pixel dimensions, same file size

Dpi	Size (inches)	Size (pixels)	File Size
2,400 dpi	1x1.5 (35mm)	2,400 x 3,600	24.7 MB
300 dpi	8x12	2,400 x 3,600	24.7 MB
150 dpi	16x24	2,400 x 3,600	24.7 MB
72 dpi	33x50	2,400 x 3,600	24.7 MB

Same dpi or image size, different pixel dimensions and file size:

Dpi	Size (inches)	Size (pixels)	File Size
300 dpi	8x12	2,400 x 3,600	24.7 MB
72 dpi	8x12	580 x 860	1.42 MB
300 dpi	5x7	1,500 x 2,100	9.0 MB
300 dpi	4x6	1,200 x 1,800	6.2 MB
300 dpi	3x5	900 x 1,500	3.9 MB

300 dpi. This means that for every linear inch of the photo, there are 300 pixels, for a total pixel count of 1,200 (4x300) x 1,800 (6x300). If the same image were scanned at 600 dpi, the count would go up to 2,400 x 3,600. Now if you wanted to print the image file at 200 dpi, you could see how big it would be by finding out how many inches with 200 pixels are available in the file. The smaller image file would give a size of 6x9 inches (1,200/200 and 1,800/200). Since the other file has a lot more pixels, the print gets bigger: 2,400/200 x 3,600/200 gives you a

12x18-inch print, an example of how more resolution offers bigger photos.

A digital camera will have an area resolution and an assigned dpi—for example, 2,272x1,704 at 180 dpi (this happens to be a 4-megapixel camera). Unfortunately, the assigned dpi for many small digital cameras is an absurd 72 dpi. This is web size and totally inappropriate. The resolution would produce enormous dimensions: 24x32 inches, in this example—something that would never fit on the web and is not at a high enough resolution for printing. If the dpi were changed to 200, the file would easily print at 8.5x11 inches, at full quality.

You have to make that change. Different uses of photos typically require different image output sizes. There are two things to consider when changing the photo's resolution: (1) changes that affect only how the pixels are squeezed together or pulled apart (which does not affect image quality except when resolution is too low or too high for the printer) and (2) alterations that actually change the number of pixels in a photo (which can affect image quality).

In Adobe products, the Image Size command has the critical elements. You will see the area resolution (along with file size in megabytes) at the top, dimensions with a resolution in the middle, and two check-box choices below. To first resize an image to find its native dimensions based on the use, be sure Resample is not checked. Then type in any number you need for output in the resolution box, and the dimensions alter accordingly. But the megabyte file size does not change at this point.

Next, you need to resize

72 dpi

300 dpi

the image to get to the right dimensions for its use (it is a good idea to save a backup file with the maximum area resolution of the original file). For example, your image at 200 dpi is 6x9 inches, but you only need something 3 inches wide for a letterhead. Check Resample, be sure Constrain Proportions is checked (this keeps the dimensions proportionally correct), and change your width to 3 inches. The whole image now resizes automatically. You'll see the megabyte size has dropped.

You can also go up in size, although you have to be careful with this. Going up in size means increasing pixels. This is called interpolation, and the software has to fill in the gaps with pixels not originally captured in the file. Sometimes this is well done, sometimes not. Always, you'll need to do some sharpening afterward.

Photos for E-mail

E-mailing photos is a great way for friends and family to stay in touch. Even grandma and grandpa are usually connected to the Internet today and love to get photos. The pros use the Internet, too, transferring image files directly to publications.

To get the most from this process, there are some things we should think about: sizing photos and photo e-mail etiquette.

One big mistake new digital photographers make is to send the exact image files created by the camera for standard e-mail correspondence. Since most photographers shoot at the maximum resolution of the camera, even a compressed file of a 3-megapixel camera can reach nearly a megabyte in size. That is too large a file to be sending casually.

Tip

Never e-mail photos directly from a digital camera without resizing them. They are too big and will likely cause problems for recipients who don't have fast Internet connections.

If image resolution (opposite) is not right for a photo's purpose, quality will decline. The low 72 dpi resolution image suffers detail loss (purists prefer ppi, but dpi is more commonly used).

Generally, you want to keep attached files under 300 KB. Many image-processing and browser programs will do this downsizing automatically. Be sure to do a "Save As" on these files, so you keep the original file.

You may, however, want to resize images yourself for particular purposes. Here are some ideas:

1. For e-mailing photos that will only be viewed on a computer, you can use a smaller file based on a lower resolution. Make your photo 4x6 at 72 dpi; then do a "Save As" in JPEG at a medium amount that gives you a file approximately 100 KB.

2. For photos to print, try this formula: 4x6 at 150 dpi, saved as a new JPEG file under 200 KB.

3. Be careful how you send multiple photos. Keep your total file size under 300 KB if possible, unless you know your recipient has high-speed access to the Internet.

4. High-speed Internet access makes the transfer of image files easier. But don't assume that because you can upload quickly, your recipient can download the same way.

How to Buy a Digital Camera

There are ten things to consider when shopping for a digital camera:

Megapixels—More megapixels let you capture more details that can be made into larger prints. If you don't need the megapixels, you can buy a less expensive camera with equal features and quality. Look for a minimum of 2 megapixels.

Lens—You need a focal-length range that will let you take pictures of the subjects you like photographing—wide angle for scenics, close-up for flowers, telephoto for people, wide angle to telephoto for travel, and so forth.

Internal processing—As noted in the chapter on digital cameras, the image sensor is only the start of a camera's capabilities. How the data are processed from that sensor can affect things like color, digital noise, speed, and more.

Tip

Never buy a digital camera based on features alone. How it handles and how you react to the controls vary enough to strongly influence how much you will like and use the camera.

How it feels in the hand—A really critical issue is always how you and the camera fit together. If you want to be happy with your camera, never buy it based on a chart of features without first trying it out in your own hands.

Ease of use—Digital cameras can have strong variations in this area. Check how difficult it is to find the important controls, how straightforward those controls are, and how clear the menus are on the LCD (including how easy they are to read).

Features needed—You may require unique features like extreme close-focusing, manual controls, manual focus, second-curtain flash sync, slow flash sync, accessory lenses, and so on.

System needs—If you have a film SLR camera, you may want a digital camera that can use your lenses or your film camera's external flash.

Accessory capabilities—If you need extras such as external flash, filters, external batteries, or other accessories, confirm that your camera choice will allow them.

LCD—The LCD monitor is a very important part of your camera. Be sure it is large enough to use comfortably; also confirm that it has decent brightness and contrast, offers good color, and is easy to see. If you need a tilting or rotating LCD, be sure your choice has that possibility.

Size—In recent years, the trend has been to smaller and smaller cameras. This might be perfect if you want a camera that can always be with you and will fit in any pocket; however, there are trade-offs with size.

Be sure to handle a camera before deciding it is right for you. How it feels in your hands is an important consideration when looking to buy one.

FOLLOWING PAGES: Jim Brandenburg believes that digital cameras have allowed him to be more lyrical and poetic in his photography.

Jim Brandenburg

WEB SITES

You'll find a lot of interesting photography sites on the World Wide Web. The ones listed here include many manufacturers and are a good source of information. Be careful about Internet photography information – anyone can put up anything on the Internet. If you are not sure of the source, you do need to be wary of the information.

ACDSee (software)
 www.acdsystems.com
Adobe Systems Inc. (software)
 www.adobe.com
ArcSoft (Panorama Maker) www.arcsoft.com
Auto FX (plug-ins and more)
 www.autofx.com
CameraWorks (daily news photos)
 www.washingtonpost.com/cameraworks/
Canon
 www.usa.canon.com
California Photo Experience (workshops)
 www.californiaphotoexperience.com
Delkin Devices (memory cards)
 www.delkin.com
Digital Journalist
 digitaljournalist.org
Digital Photography Review
 www.dpreview.com
Epson
 www.epson.com
Fujifilm
 www.fujifilm.com
Jasc (software)
 www.jasc.com
Kingston Technology (memory cards)
 www.kingston.com
Kodak
 www.kodak.com
Lexar Media (memory cards)
 www.lexarmedia.com
Minolta
 www.minoltausa.com
National Association of Photoshop Professionals
 www.photoshopuser.com
National Geographic Society
 www.nationalgeographic.com
nikMultimedia (plug-ins)
 www.nikmultimedia.com

Nikon
 www.nikonusa.com
North American Nature Photography Association
 www.nanpa.org
Olympus
 www.olympusamerica.com
Palm Beach Photographic Centre (workshops)
 www.workshop.org
PCPhoto magazine
 www.pcphotomag.com
Pentax
 www.pentax.com
Photodex (software)
 www.photodex.com
Professional Photographers of America
 www.ppa-world.org
Rob Galbraith Digital Photo Insights
 www.robgalbraith.com
Rob Sheppard digital videos
 www.rsphotovideos.com
Santa Fe Photographic and Digital Workshops
 www.santafeworkshops.com
Schneider Optics (filters, accessory lenses)
 www.schneideroptics.com
Secrets of Digital Photography –
 www.digitalsecrets.net
SimpleTech (memory cards)
 www.simpletech.com
Ulead (software)
 www.ulead.com
Verbatim (CD and DVD media)
 www.verbatim.com
Vivid Details Test Strip (plug-in)
 www.vividdetails.com
Wacom (graphics tablets)
 www.wacom.com

MAGAZINES AND BOOKS

Photography Magazines

American Photo. Bimonthly publication that emphasizes glamour and celebrity photographers and photography.
BT Journal. Quarterly newsletter about wildlife and digital photography.
Digital Camera. Bimonthly magazine about digital cameras and accessories.
The Digital Image. Quarterly publication

from Lepp & Associates on digital photography.

Digital Photographer. Quarterly publication about digital cameras and accessories.

Digital Photo Pro. Bimonthly magazine about how professional photographers work digitally.

F8 and Be There. Photo newsletter about outdoor and travel photography.

The Natural Image. Quarterly publication from Lepp & Associates on nature photography.

Nature Photographer. Quarterly publication about nature photography.

Nature's Best. Quarterly magazine showcasing nature photography.

Outdoor Photographer. Monthly (11 issues) magazine covering all aspects of nature and outdoor photography.

PCPhoto. Monthly (9 issues) publication about digital photography.

Petersen's PhotoGraphic. Monthly general photography magazine.

Photo District News. Monthly publication about professional photography.

Photo Life. Bimonthly Canadian photography magazine.

Popular Photography & Imaging. Monthly general photography magazine.

Shutterbug. Monthly general photography magazine.

Photography Books

Ansel Adams, *Examples, the Making of 40 Photographs,* Little, Brown

Ansel Adams, *The Print,* Little, Brown

Theresa Airey, *Creative Digital Printmaking,* Amphoto

William Albert Allard, *Portraits of America,* National Geographic Books

Leah Bendavid-Val, Sam Abell – *The Photographic Life,* Rizzoli

Niall Benvie, *The Art of Nature Photography,* Amphoto

David Blatner, Bruce Fraser, *Real World Photoshop 7,* Peachpit Press

Peter K. Burian and Robert Caputo, *National Geographic Photography Field Guide,* National Geographic Society

Michael Busselle, *Creative Digital Photography,* Amphoto

John Paul Capognigro, *Adobe Photoshop Master Class,* Adobe Press

Robert Caputo, *National Geographic Photography Field Guide: People & Portraits,* National Geographic Society

Robert Caputo, *National Geographic Photography Field Guide. Landscapes,* National Geographic Society

Jack Davis, *The Photoshop 7 WOW! Book,* Peachpit Press

William Cheung, *Landscapes – Camera Craft,* Sterling

Elliot Erwitt, *Snaps,* Phaidon

Joe Farace, *Digital Imaging: Tips, Tools and Techniques for Photographers,* Focal Press

Tim Fitzharris, *National Park Photography,* AAA Publishing

Bill Fortney, *Great Photography Workshop,* Northword Publishing

Barry Haynes, Wendy Crumpler, *Photoshop 7 Artistry,* New Riders

John Hedgecoe, many books, one of the best how-to photo authors

Craig Hoeshern, Christopher Dahl, *Photoshop Elements for Windows and Macintosh,* Peachpit Press

Chris Johns, *Wild at Heart,* National Geographic Books

Eastman Kodak Co., *Kodak Guide to 35mm Photography,* Sterling

Scott Kelby, *The Photoshop Book for Digital Photographers,* New Riders

Scott Kelby, *Photoshop 7 Down and Dirty Tricks,* New Riders

Steve McCurry, *Portraits,* Phaidon

Joe Meehan, *The Photographer's Guide to Using Filters,* Amphoto

Gordon Parks, *Half Past Autumn,* Bullfinch

B. Moose Peterson, *The D1 Generation,* Moose Press

Rick Sammon, *Rick Sammon's Complete Guide to Digital Imaging,* W.W. Norton

John Shaw, many books, superb nature photography how-to

Rob Sheppard, *Basic Scanning Guide for Photographers,* Amherst Media

Rob Sheppard, *The Epson Complete Guide to Digital Printing,* Lark Books

James L. Stanfield, *Eye of the Beholder,* National Geographic Society

National Geographic Photography Field Guide Digital

Rob Sheppard

Published by the National Geographic Society

John M. Fahey, Jr., *President and Chief Executive Officer*

Gilbert M. Grosvenor, *Chairman of the Board*

Nina D. Hoffman, *Executive Vice President*

Prepared by the Book Division

Kevin Mulroy, *Vice President and Editor-in-Chief*

Charles Kogod, *Illustrations Director*

Marianne R. Koszorus, *Design Director*

Staff for this Book

Charles Kogod, *Editor*

Carolinda E. Averitt, *Text Editor*

Cinda Rose, *Art Director*

Kay Hankins, *Designer*

Michelle Harris, *Researcher*

Bob Shell, *Technical Consultant*

R. Gary Colbert, *Production Director*

Lewis Bassford, *Production Project Manager*

Meredith C. Wilcox, *Illustrations Assistant*

Mark Wentling, *Indexer*

Manufacturing and Quality Control

Christopher A. Liedel, *Chief Financial Officer*

Phillip L. Schlosser, *Financial Analyst*

John T. Dunn, *Technical Director*

Alan Kerr, *Manager*

One of the world's largest nonprofit scientific and educational organizations, the National Geographic Society was founded in 1888 "for the increase and diffusion of geographic knowledge." Fulfilling this mission, the Society educates and inspires millions every day through its magazines, books, television programs, videos, maps and atlases, research grants, the National Geographic Bee, teacher workshops, and innovative classroom materials.

The Society is supported through membership dues, charitable gifts, and income from the sale of its educational products. This support is vital to National Geographic's mission to increase global understanding and promote conservation of our planet through exploration, research, and education.

For more information, please call 1-800-NGS LINE (647-5463) or write to the following address:

National Geographic Society
1145 17th Street N.W.
Washington, D.C. 20036-4688 U.S.A.

Visit the Society's Web site at www.nationalgeographic.com.

Library of Congress Cataloging-in-Publication Data
Sheppard, Rob
 National Geographic photography field guide: digital : secrets to making great pictures / text and photographs by Rob Sheppard.
 p. cm.
 ISBN 0-7922-61887
 1. Photography--Digital techniques. I. National Geographic Society (U.S.) II. Title.
TR267.S535 2003
775--dc22 2003059340

FRONT COVER: Although it is composed of pixels, rather than grain, this digital image is very much a true photograph.

Bruce Dale

LOOK FOR THESE COMPANION VOLUMES
WHEREVER BOOKS ARE SOLD

0-7922-5676-X

0-7922-6499-1

0-7922-6498-3

0-7922-6878-4

OTHER NATIONAL GEOGRAPHIC PHOTOGRAPHY BOOKS

- Andes
 0-7922-6430-4

- Broken Empire
 0-7922-6432-0

- Cuba
 0-7922-7501-2

- Eye of the Beholder
 0-7922-7379-6

- Fashion
 0-7922-6416-9

- National Geographic
 Photographs: The Milestones
 0-7922-7520-9

- National Geographic
 The Photographs
 0-87044-986-9

- National Geographic
 The Wildlife Photographs
 0-7922-6356-1

- Portraits of America
 0-7922-6418-5

- Remains of a Rainbow
 0-7922-6412-6

- Seeing Gardens
 0-7922-7956-5

- Stories on Paper and Glass
 0-7922-6434-7

- Through the Lens
 National Geographic
 Greatest Photographs
 0-7922-6164-X

- Women Photographers
 at National Geographic
 0-7922-7689-2

For more than 100 years the name National Geographic has been synonymous with excellence in photography. Some of the finest photographers in the world have traveled the globe capturing memorable images for the pages of the Society's magazines and publications.

Praise for National Geographic Photography Field Guide:

"Here is a photography book that inspires as it informs. Even better are the rich stories of how (and why) National Geographic photographers make their photos."
-David Schonauer, *American Photo magazine*

AUTHOR ROB SHEPPARD Sammi Sheppard

Rob Sheppard, author, digital expert, and editor of PCPhoto and Outdoor Photo magazines explains the secrets to making great digital photographs. This engaging and informative guide also shows how to join the digital revolution even if you still shoot film.

- How to select a digital camera

- Tips for getting the best results with a digital cam

- How digital cameras can make better pictures than film cameras

- Secrets of getting the most out of a digital darkroom

- Photography Web sites

ISBN 0-7922-6188

9 780792 261889

$21.95 U.S./$34.95 CANA